African Majesty

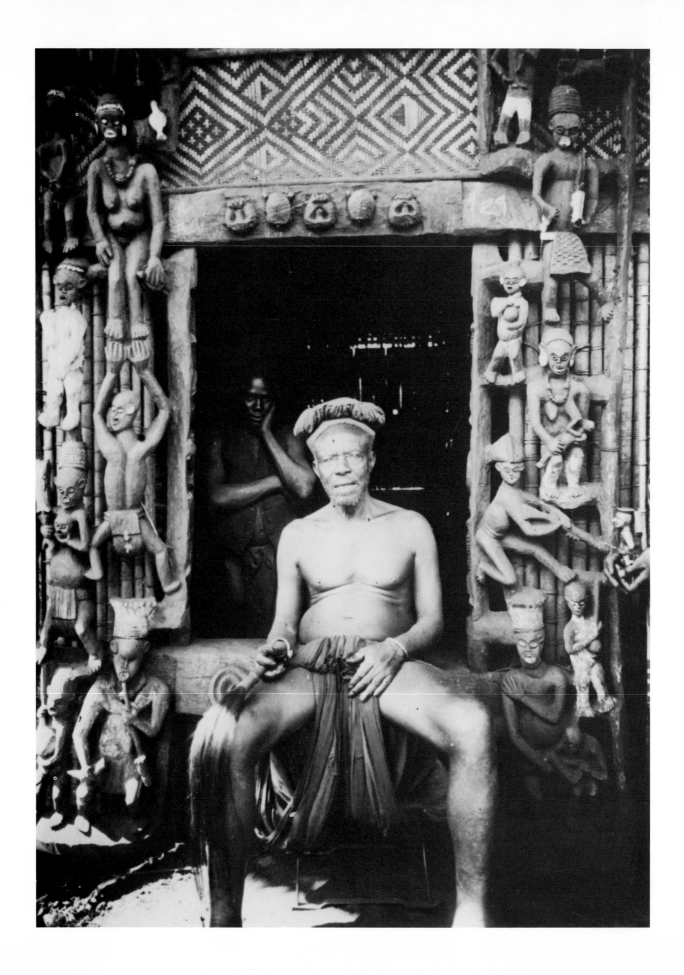

William Fagg

African Majesty

From Grassland and Forest

With an introduction by Alan G. Wilkinson

The Barbara and Murray Frum Collection
May 22 – July 12, 1981

Art Gallery of Ontario
Musee des beaux-arts de l'Ontario
Toronto/Canada

Copyright © 1981 Art Gallery of Ontario
All rights reserved
ISBN: 0-919876-73-0

Canadian Cataloguing in Publication Data

Fagg, William, 1914-
 African majesty

Catalogue of an exhibition of the Barbara and
Murray Frum Collection, held at the Art Gallery of
Ontario, May 22-July 12, 1981.
ISBN 0-919876-73-0

1. Sculpture, African—Exhibitions. 2. Frum,
Barbara —Art collections. 3. Frum,
Murray—Art collections. I. Art Gallery of
Ontario. II. Title.

NB1080.5.F33 730′.96′0740113541 C81-094448-0

Graphic Design:
Michael van Elsen Design Inc.

Photography by Photographic Services,
Art Gallery of Ontario

Typeset in Canada
by Trigraph Inc.

Printed and bound
by Herzig Somerville Limited

Frontispiece:
Photo of Pokam, twelfth *Fon* of Baham,
in front of No. 20, *Door Frame*.
Photo by Father Christol, 1925.

The Cover:
No. 26, *Commemorative Statue of Queen Nana with Child*
BANGWA, KINGDOM OF BATUFAM/ Cameroon
Wood
101.3 cm (39⅞″)

Royal Ceremonial Staff
LUBA/ Zaïre
Wood, copper, fibre, iron,
leather thong
H. 141.6 cm (55¾″)
detail

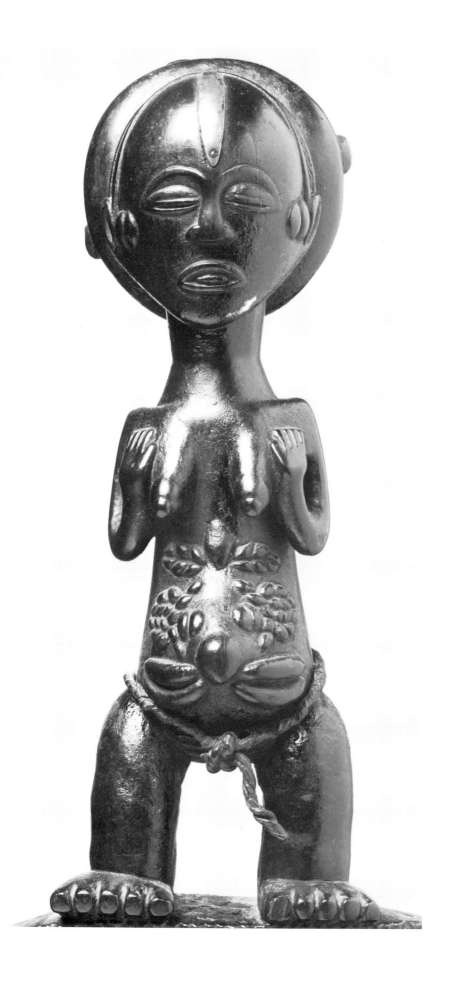

Contents

Acknowledgements

I would like to thank my colleagues at the Art Gallery of Ontario for their help with the preparation of this catalogue and exhibition: William J. Withrow, Director; Dr. Roald Nasgaard, Chief Curator; Barry Simpson, Exhibition Co-ordinator; Eva Robinson, Registrar; Kathy Wladyka, Assistant Registrar; my secretary Josephine Moore; Ed Zukowski, Conservator; John Ruseckas, Chief Preparator, and the following members of his staff – Jim Bourke, Wilbert Headley, Coleridge Lewis, Ben Lynch; Denise Bukowski, Head of Publications and Design; and Maia Sutnik, Co-ordinator of Photographic Services, and her assistant Faye Craig. I am most grateful to Larry Ostrom, Head Photographer, Powey Chang, Photographer, and Richard Plander, Technician, for their understanding of the often difficult and challenging problems involved in lighting and photographing three-dimensional works.

I am grateful to Hermione Waterfield of Christie's, London, England, for her interest and advice. I would also like to thank Michael van Elsen, the designer of this catalogue. Hershel Okun has been of great assistance with the design and layout of the exhibition.

It has been a great pleasure working with William Fagg, one of the world's leading authorities on African art. His catalogue entries on all works in the exhibition will be of great interest to collectors and scholars, and represent an important addition to his enormous contribution to African scholarship.

In the Foreword William Withrow has thanked Barbara and Murray Frum for making this exhibition possible. I would like to add my own thanks for their co-operation and help at all stages of the planning and design of the exhibition and the production of the catalogue. In many ways Barbara and Murray Frum are ideal collectors: they collect with a love and knowledge of what is best in African art, and have an infectious way of sharing their enthusiasm with others.

ALAN G. WILKINSON,
Curator of Sculpture,
Art Gallery of Ontario

Foreword

One of the most enlightened of recent trends is the growing fascination with the so-called "primitive arts." Although the sculptures of Africa, Oceania, and ancient America have been collected and coveted for centuries, the popularity of such exhibitions as *The Art of the Pacific Islands* at the National Gallery of Art, Washington, and *The Treasures of Ancient Nigeria* at the Metropolitan Museum of Art, New York, certainly suggests that the astonishing achievements of these ancient societies are finally receiving their due. Important expositions of tribal art are being mounted by the pre-eminent museums of Canada and the United States, museums that until now have been pre-occupied with the history of Western art. At the Art Gallery of Ontario we exhibited Northwest-Coast Indian art in the show *Form and Freedom* in 1977. In 1978 at the National Gallery of Canada, *Twenty-Five African Sculptures* included seventeen carvings owned by Barbara and Murray Frum. This exhibition at the Art Gallery of Ontario, however, marks the first time the Frums' African Collection has been exhibited and catalogued in its entirety.

As no doubt has happened with many passionate collectors, the Frums' love for African sculpture developed almost by accident. Beginning with a casual purchase of an attractive but otherwise unremarkable mask, they quickly discovered that African artists had produced sculptures that rivalled the finest achievements of any culture or period. Unlike those of other art forms, however, the masterworks of African art were still available to private collectors. Works that had been locked away in private collections for generations were suddenly finding their way to the salerooms and dealers of London, Paris, Brussels, and New York. As well, material that had been cherished and hidden away from European colonial officials and traders for one hundred or perhaps two hundred years had come to light as a result of the political turmoil in Africa.

Undoubtedly the exhibition *Arts primitifs dans les ateliers d'artistes* at the Musée de l'Homme in Paris in 1967 was instrumental in shaping the Frums' attitude towards African art. Like Matisse, Picasso, Brancusi, and Modigliani in the early years of this century, the Frums admire and collect primitive works not as ethnographic curiosities but as superb creations that can take their rightful place beside the greatest sculpture in the Western tradition.

As early as 1920, the English critic Roger Fry wrote of Negro art: "I have to admit that some of these things are great sculpture – greater, I think, than anything we produced even in the Middle Ages." Having seen the Metropolitan Museum exhibition's superb sixteenth- and seventeenth-century Benin bronzes from Nigeria, or the Bamileke *Statue of Queen Nana with Child* (catalogue Number 26), the Kota and Fang *Reliquary Figures* (Nos. 29 and 30), and the Yombe *Seated Female with Child* (No. 35) from this exhibition, few would question Roger Fry's prophetic judgement.

The Frums have made no attempt to assemble a comprehensive ethnographic group of objects to represent each of the dozens of African tribes and geographic regions. Rather, the emphasis has been on individual aesthetic and sculptural qualities. Each carving has been chosen on its merits from

the very best examples available. The fact that almost every major publication on African art in the last few years has included works in this collection attests to the Frums' standard of taste and judgement. They also have an irrepressible and passionate curiosity to understand the historical and cultural context in which each carving was conceived, and to trace its provenance. Their extensive correspondence and conversations with scholars, collectors, and dealers have inevitably assisted William Fagg in compiling the notes for this catalogue.

We are indeed fortunate to have organized this exhibition of one of the finest collections of African art on this continent, and are deeply indebted to Barbara and Murray Frum for making this possible. It is appropriate that a collection of this importance has been catalogued by the distinguished scholar William Fagg, former Keeper of the Museum of Mankind, British Museum.

WILLIAM J. WITHROW
Director,
Art Gallery of Ontario

A Revolution in Consciousness: African Art and the Western Tradition

"The encounter of primitive, chiefly African, art with modern art represents one of the major metamorphoses of our epoch."
– André Malraux

It was the artists – Gauguin in the 1890s, then in 1904-05 Vlaminck, Derain, Picasso, and Matisse in Paris, and Kirchner and Nolde in Germany – who first collected and drew inspiration from the sculpture of Africa and Oceania. And it was they who set in motion the perception of these extraordinarily inventive carvings as works of art rather than ethnological curiosities.

"People are always talking about the influence the Negroes had on me," Pablo Picasso told his friend Malraux. "We all loved the fetishes. Van Gogh said his generation had Japanese Art – we have the Negroes." For Picasso the African masks and sculpture that startled Paris at the end of the nineteenth century "were magical objects....They were weapons – to keep people from being ruled by spirits, to help them free themselves."

The discovery of so-called "primitive" art freed Picasso and the artists of his generation from the stultifying limits of the Greco-Roman tradition, which had ruled European painting and sculpture since the Renaissance. "The great error is the Greek," Paul Gauguin wrote, "however beautiful it may be.... You will always find nourishing milk in the primitive arts, but I doubt if you will find it in the arts of ripe civilizations."

How prophetic he was. By the 1920s Henry Moore was intent on removing "the Greek spectacles from the eyes of the modern sculptor." He studied and absorbed the rich and varied sculptural achievements of the rest of mankind: the Prehistoric, Sumerian, Egyptian, Chinese, Indian, Etruscan, African, Oceanic, Pre-Columbian, and Northwest-Coast Indian traditions.

Probably the earliest record of a European artist's reaction to primitive art is Albrecht Dürer's famous diary entry of 1520 describing the objects that Cortès sent from Central America to the Spanish emperor Charles V. He wrote of "all sorts of marvellous objects for human use much more beautiful to behold than things spoken of in fairy tales....And in all the days of my life, I have seen nothing which rejoiced my heart as these things – for I saw among them wondrous artful things and I wondered over the subtle genius of these men in strange countries."

Dürer's encounter with non-European art and artifacts was a rare experience in the sixteenth century. By the seventeenth century a few African carvings were finding their way to Europe, notably four stone figures (now in the Museo Pigorini, Rome) that were reputedly brought from the Lower Congo in 1695. Also among the earliest works brought to Europe from Africa were the Sherbro ivories, which were first commissioned by the Portuguese at the beginning of the sixteenth century. These splendid salt-cellars, spoons, forks, and hunting horns combined the aesthetic values of Europe with the stylistic features of *Nomoli* carvings (a fine example can be seen in the Frum Collection, No. 2).

We know that a Portuguese, Diego Cao, collected ivories from the Congo in 1486. Some African pieces, including several ivory trumpets, were among the curiosities owned by Archduke Fer-

9

dinand of Tyrol. A bill of sale exists that shows Charles the Bold bought from a Portuguese in 1470 several wooden sculptures from Africa. It is also recorded that Francis I in 1527 admired some strange statuettes and ivory lance-tips of African origin when visiting a rich shipbuilder in Dieppe. In 1668 a Dutch geographer called Dapper was the first to describe the city of Benin. Despite such an intriguing record, however, it seems that for the first four hundred years of contact, African objects in general were viewed with disdain; to Western eyes they represented the depravity of the natives. Occasionally works were sent to Europe as examples of heathen practices, to encourage support of missionary societies.

It was only with the colonization of Africa in the second half of the nineteenth century that ethnographic studies began in earnest. Territories that until then had resisted penetration were being explored and settled, and carvings and artifacts were collected on a massive scale. It was this period that saw the foundation of the great museums of Berlin, Brussels, Dresden, Leipzig, London, Paris, and Rome. With the arrival in Europe of the extraordinary bronze castings taken in the Punitive Expedition against Benin in 1897, the deliberate pursuit of African objects for the enrichment of European collections began.

The first European artist to incorporate the sculptural values and principles of non-European art in his own work was Paul Gauguin. He found his "nourishing milk" in arts as diverse in time and place as ancient Greece, Java, Egypt, and Oceania, borrowing figurative and decorative elements from all these sources. His lifestyle, his rejection of the values of *bourgeois* society, and his decision in 1891 to "flee to the woods on an island in Oceania, and to live there on ecstacy, on calm and on art... far from this European struggle for money," have ever since represented the ultimate romantic expression of Western man's urge to escape from his own civilization in search of a simpler, more natural existence.

Few works could better illustrate Gauguin's interest in Polynesian legend and art than the tamanu wood carving *Hina and Te Fatou* (now in the collection of the Art Gallery of Ontario) made during his first stay in Tahiti from 1891-93. The concept of the goddess of the moon and the god of the earth in conversation derives from an ancient myth, while the decorative motifs at the base of the sculpture are features found in the art of the Marquesas Islands. The sculpture was exhibited in Paris in the great Gauguin retrospective at the Salon d'Automne in 1906, at that crucial moment in the history of twentieth-century art when the most advanced painters of the time – Vlaminck, Derain, Picasso, Matisse, and Brancusi – were discovering the art of Oceania and Africa. The use of primitive sources in many of Gauguin's paintings and sculptures in that exhibition was undoubtedly an inspiration for these artists. They themselves were discovering and collecting African art, which was soon to become one of the two major influences in the creation of Cubism, the most important pictorial revolution of the twentieth century.

1904 is generally accepted as the year in which French painter Maurice de Vlaminck perceived African sculpture not – as he had on earlier visits to the Trocadéro (now the Musée de l'Homme) – as

"barbaric fetishes," but as works that profoundly moved him. He bought two sculptures that he had seen in a bistro, and was later given three more carvings by a friend of his father. André Derain was especially excited by one of these, a white Fang mask, which he persuaded Vlaminck to sell to him. Ambroise Vollard borrowed the mask and had it cast in bronze at the foundry used by sculptor Aristide Maillol. A revolution in twentieth-century art was under way.

The first African works these artists saw and collected were in fact of only average quality. But their interest led others to heightened sensitivity to African sculpture. From then on, Vlaminck wrote, "there started the great hunt for African art."

It was in André Derain's studio in the rue Tourlaque that, Vlaminck maintained, Matisse and Picasso saw African art for the first time. Gertrude Stein, on the other hand, recounted that in 1906, after the summer at Gosol, Picasso returned to Paris "and became acquainted with Matisse through whom he came to know African sculpture." With his 1906 painting *Les Baigneuses*, Derain became one of the most advanced and innovative painters of his generation, combining for the first time the influences of Cézanne and of African sculpture. It is probably a mistake, however, to try to identify individual examples of African art that may have inspired him. John Golding relates the head of the central bather in Derain's *Les Baigneuses* to African sculpture from the French Congo, while the Cameroon *Statue of Queen Nana with Child* (No. 26), one of the finest carvings in the Frum Collection, reminds William

Fagg of the same figure in Derain's painting.

Although the influence of African art was restricted to relatively few of Derain's works, it was of immense importance in Picasso's painting and sculpture during his Negro Period (1907-09). Although Matisse almost certainly showed Picasso examples of African sculpture, the full impact on his art did not appear until the following year, when he was working on *Les Demoiselles d'Avignon*. It was probably after a visit to the Trocadéro that Picasso reworked the heads of the two right-hand figures, whose features resemble Kota reliquary figures from Gabon (Nos. 29 and 33 in this catalogue are outstanding examples).

The "primitivism" of Picasso's wood carvings of 1907 reflects his interest both in Gauguin and in African and Oceanic sculpture, but again the influences are generalized; often one can only point to a tribal style or type. For example, the Art Gallery of Ontario's little Picasso wood-carving, *Poupée* (1907), is clearly indebted to the squat forms of Marquesan "Tiki" sculptures, an example of which he owned. Picasso admired the conceptual character of African art which was figurative without being dictated by natural appearances. As Gertrude Stein wrote, during his Negro Period he was struggling, to express, as do the African sculptors, "things seen not as one knows them but as they are when one sees them without remembering having looked at them." Picasso didn't just assimilate the forms of African art on an intellectual, purely formal level; he also responded in a more emotional way to the exotic sense of magic and the expressive character of much primitive sculpture. Long after his Negro Period he again

was inspired by African sculpture in the frenzied mask-like head of the figure at left in his great painting, *The Dance* (1925), in the Tate Gallery.

Henri Matisse shared Picasso's and Derain's enthusiasm for African art, although its impact on his work was minimal and well assimilated. Amedeo Modigliani's elongated stone head, on the other hand, were clearly based on Guro and Baule masks from the Ivory Coast. With Constantin Brancusi it is usually difficult to identify specific sources for his African-inspired sculpture, with the notable exception of his 1914 bronze *The First Cry*, which is stylistically close to certain ancestor figures from the Upper Niger. Alberto Giacometti's 1926 *The Spoon Woman* and Max Ernst's 1944 *Bachelor with Beating Heart* are obviously indebted to Dan rice spoons from the Ivory Coast.

In Germany the artists of the Brücke group discovered primitive art in 1904 (the same year as did Vlaminck and Derain in Paris) when Ernst Kirchner saw both African and Oceanic art in the Ethnological Museum at Dresden. Like Gauguin, the group also embraced a romantic longing for the primitive life. Primitive art was, as Emil Nolde wrote, "raised up to the level of art...pleasing, ripe original art." What he admired was "its absolute primitiveness, its intense, often grotesque expression of strength and life in its very simplest form." Karl Schmidt-Rottluff's paintings and woodcuts are populated with African masks. His wood-carving *Worker with Cap* has the proportions of a Babembe ancestor figure, while Kirchner's "Cameroonian furniture" of the early 1920s, such as the large *Mirror Frame* now in Nürnberg, was

inspired by houseposts and door frames like the magnificent Baham *Door Frame* (No. 20) in this exhibition.

By the close of the nineteenth century, scholars too were beginning to appreciate the aesthetic qualities of African sculpture, instead of focussing exclusively on its decorative aspects. The two disparate approaches – the ethnological study of the content and context of a work and the appreciation of its aesthetic character – have gradually in this century come together. Today any writing on African art that ignored either the artistic merit of a carving or its cultural and religious background would be considered one-sided and incomplete. Such balance is admirably achieved in, for example, William Fagg's catalogue notes on the *Statue of Queen Nana with Child* (No. 26), in which he combines his justified praise of this work as an outstanding sculptural achievement with an explanation of the geographical and cultural context in which the carving was made.

Despite the obvious inaccuracy and pejorative implications of the term, "primitive art" continues to be used to describe the early art of many regions of the world – Africa, Oceania, America, Mexico, and South America. Indeed proper recognition has long been denied the African artist by this easy and superficial categorization of his creativity. The term had its origin in nineteenth-century anthropology and in the evolutionary theories of Charles Darwin. Comparing the anti-naturalistic style of most African sculpture with the Greco-Roman tradition of European art, anthropologists found African carvings crude and primitive and

concluded that the sculptors lacked the necessary skills to produce the sophisticated representational works that for European taste were still the norm.

For similar reasons the anonymity of the African artist was unquestionably accepted for a long time, simply because no one bothered to ask for the artists' names. Now, however, publications and exhibitions are beginning to avoid the term "primitive," substituting objective titles such as *The Tribal Eye, The Sculpture of Africa, Nigerian Images,* and *Sculpture of the Tellem and the Dogon.* As we become familiar with the extraordinary achievements of African art – the classical Ife and Benin bronzes or the *Statue of King Nguambo* (No. 21), which has the expressionist power of Rodin's *Balzac* – the derogatory overtones of the word "primitive" seem anachronistic and ignorant remnants of the nineteenth century. Led by such pioneering figures as William Fagg, we are finally ready to marvel at the majesty of an art that we never quite saw before.

ALAN G. WILKINSON

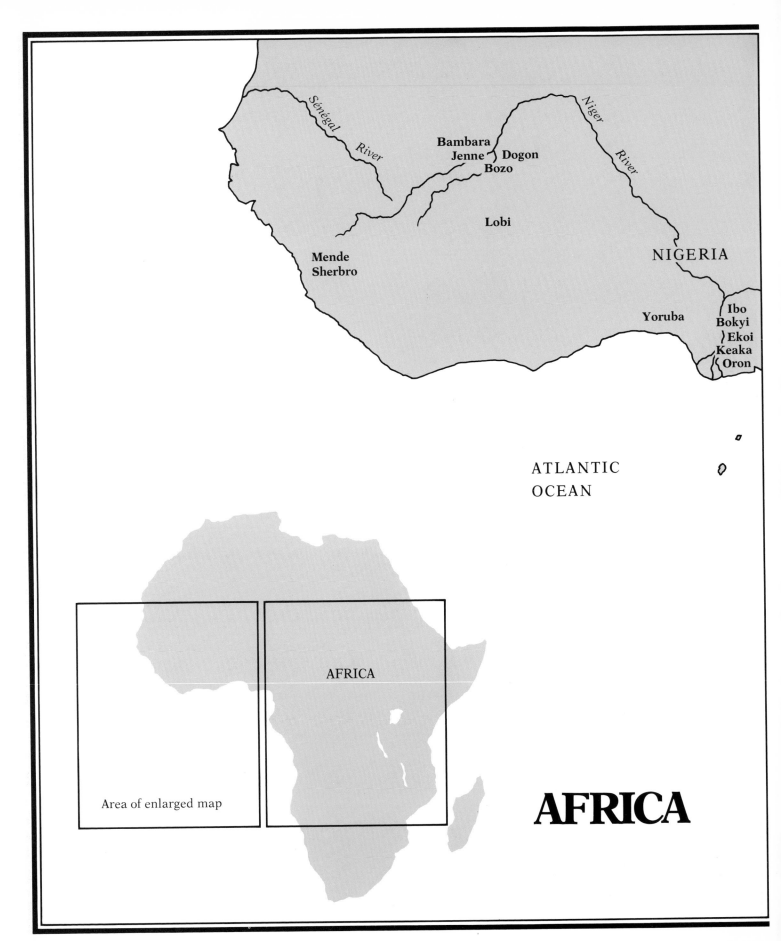

Sénégal River

Niger River

Bambara
Jenne **Dogon**
Bozo

Lobi

NIGERIA

Mende
Sherbro

Yoruba

Ibo
Bokyi
Ekoi
Keaka
Oron

ATLANTIC
OCEAN

AFRICA

Area of enlarged map

AFRICA

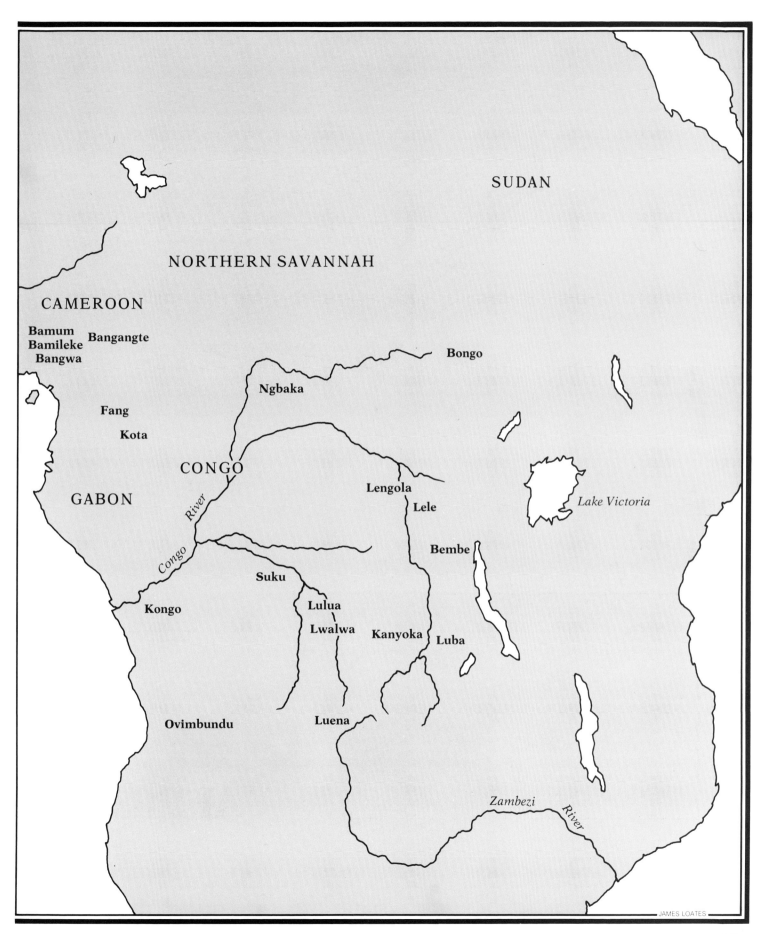

SUDAN

NORTHERN SAVANNAH

CAMEROON

Bamum
Bamileke Bangangte
Bangwa

Bongo

Ngbaka

Fang

Kota

CONGO

Lengola

GABON

Lele

Congo River

Lake Victoria

Congo River

Bembe

Suku

Kongo

Lulua

Lwalwa

Kanyoka Luba

Ovimbundu

Luena

Zambezi River

Northern Savannah

1
Head
JENNE/Mali
Terracotta
L. 10.8 cm (4¼″)

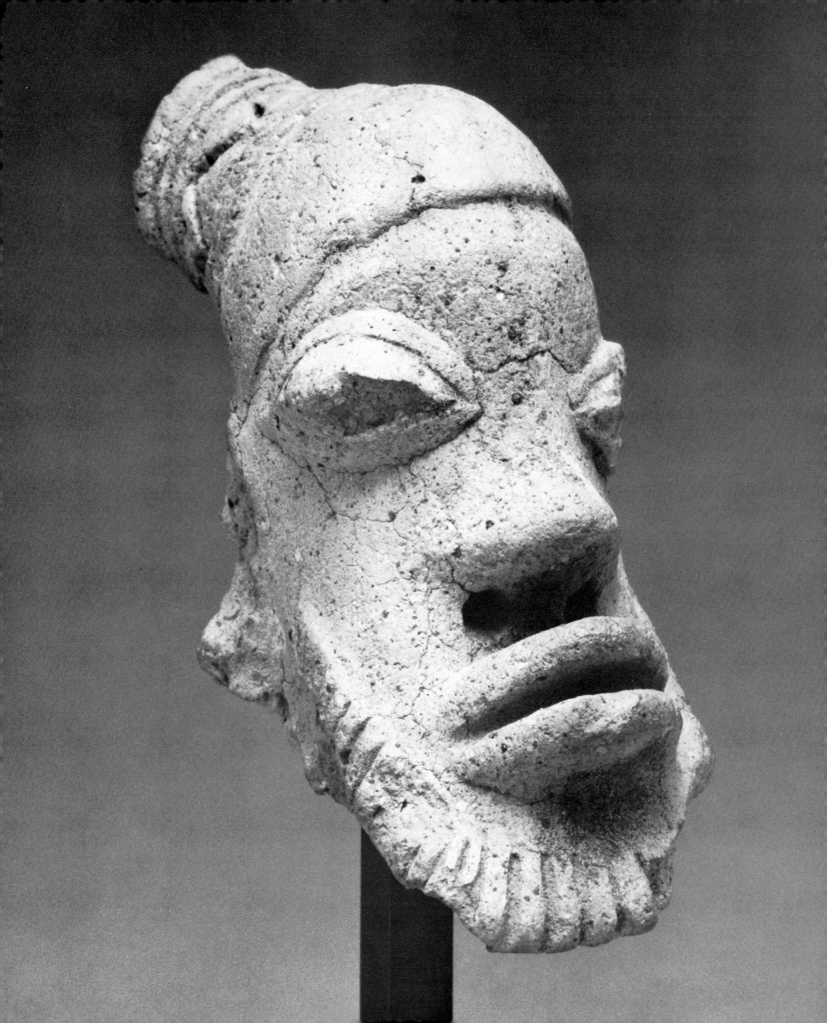

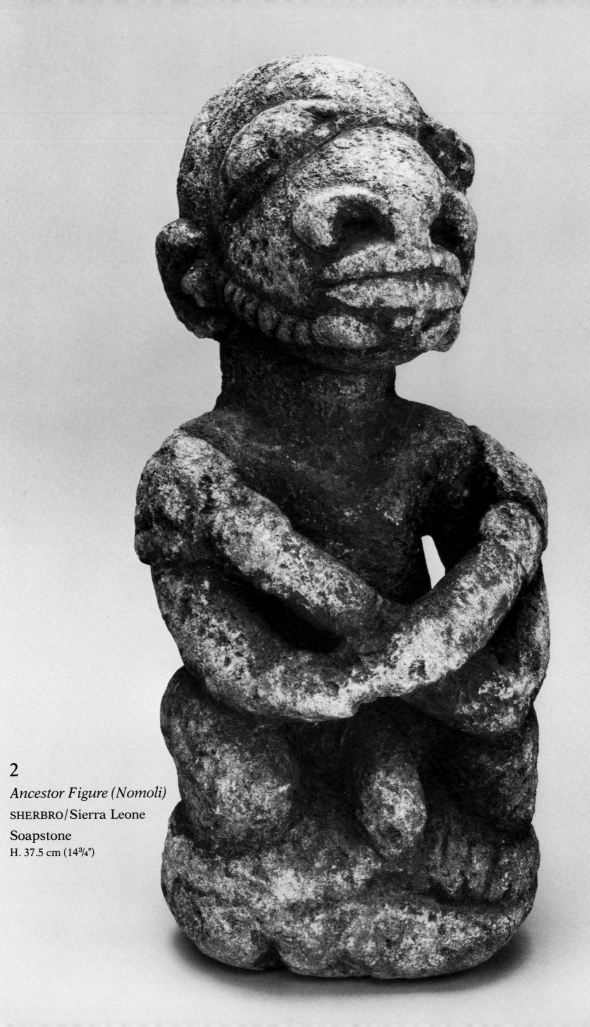

2

Ancestor Figure (Nomoli)
SHERBRO/Sierra Leone
Soapstone
H. 37.5 cm (14¾″)

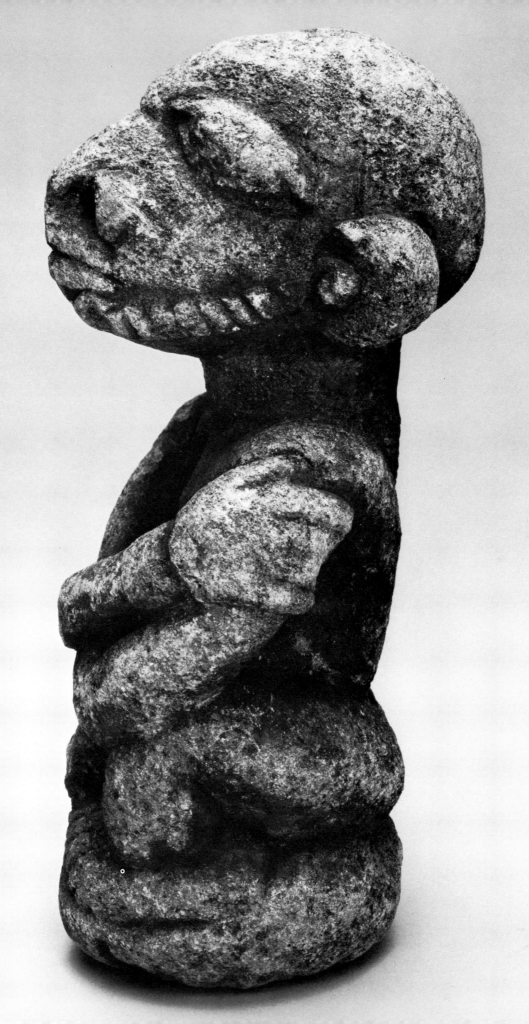

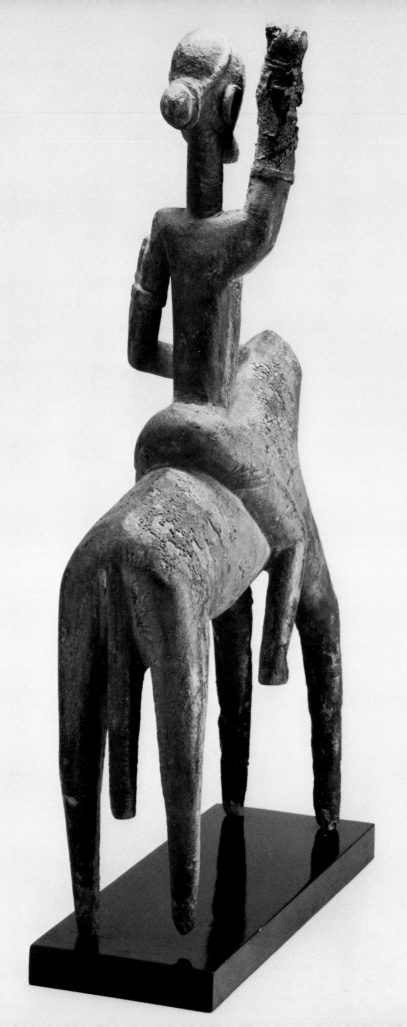

3
Horse and Rider
DOGON/Mali
Wood, iron, traces of
sacrificial coating
H. 56.5 cm (22¼″)

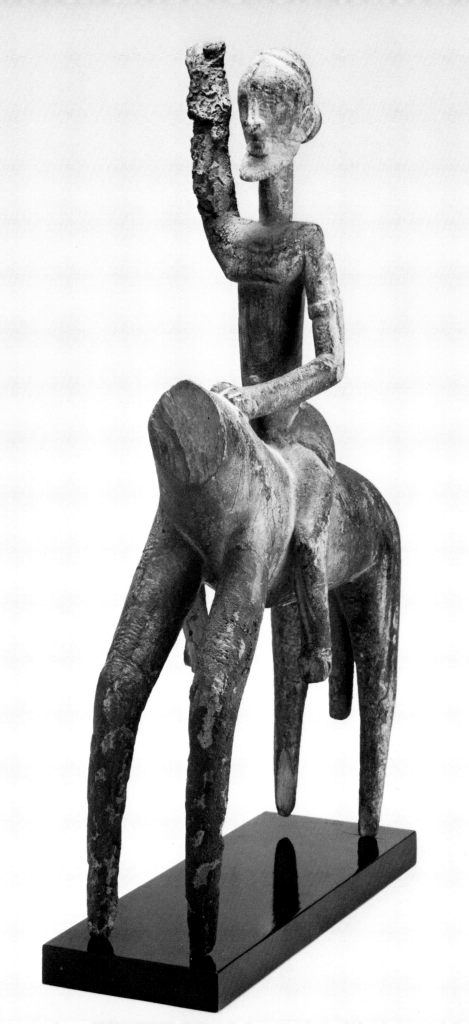

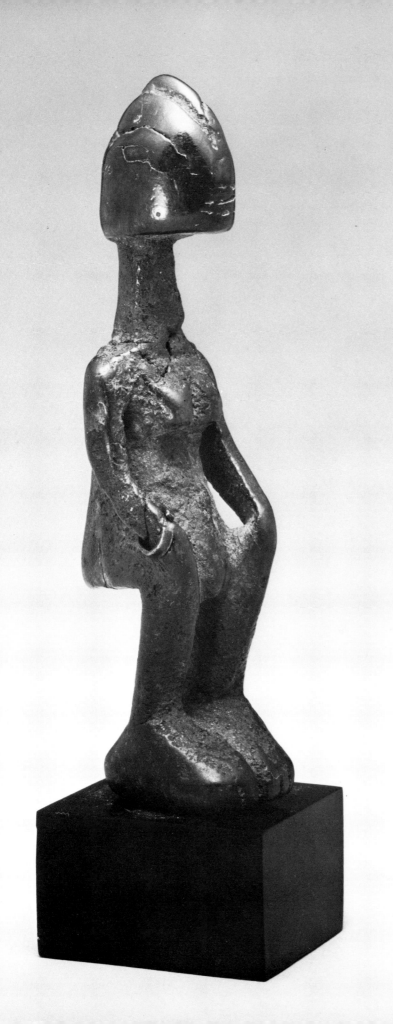

4
Diviner's Charm
DOGON / Mali
Wood, iron
H. 8.9 cm (3½″)

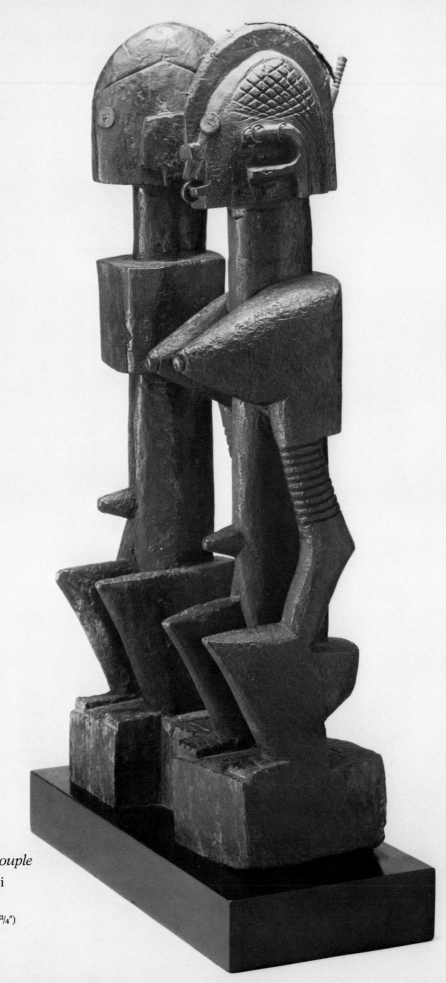

5
Primeval Couple
DOGON / Mali
Wood, iron
H. 57.8 cm (22³/₄″)

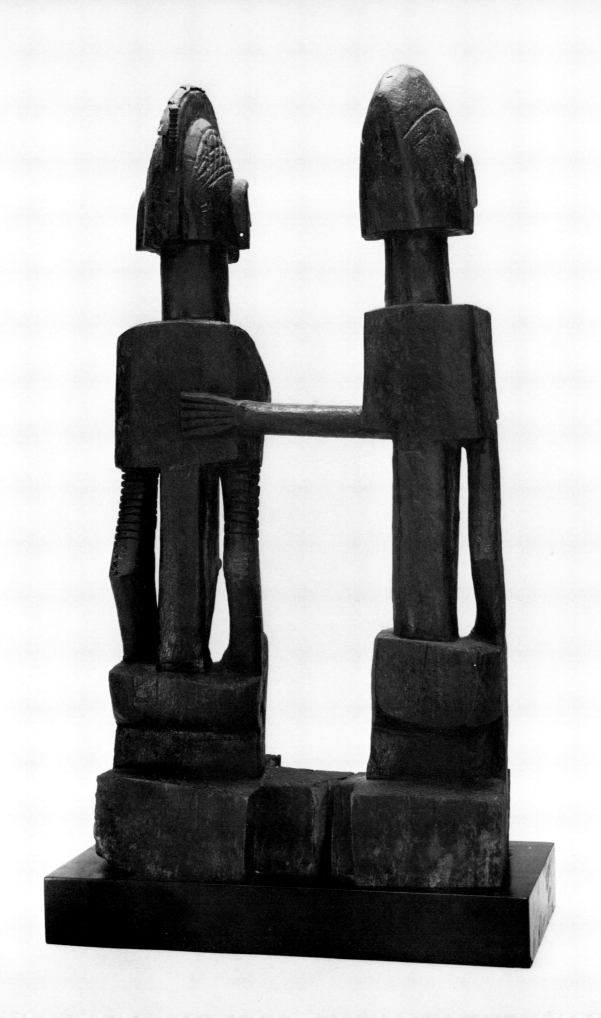

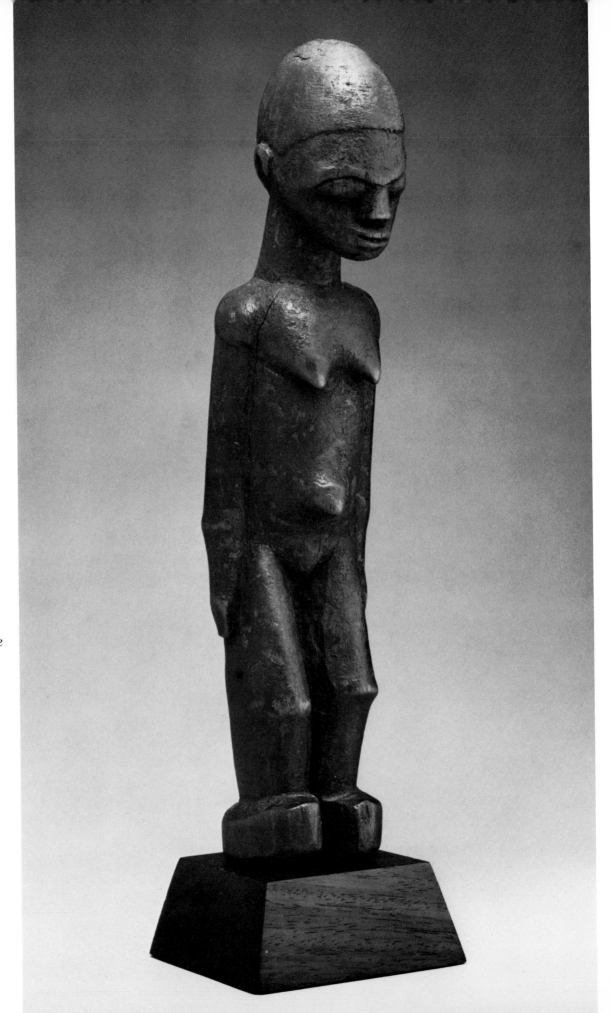

6
Female Standing Figure
LOBI/Upper Volta
Wood
H. 18.1 cm (7⅛″)

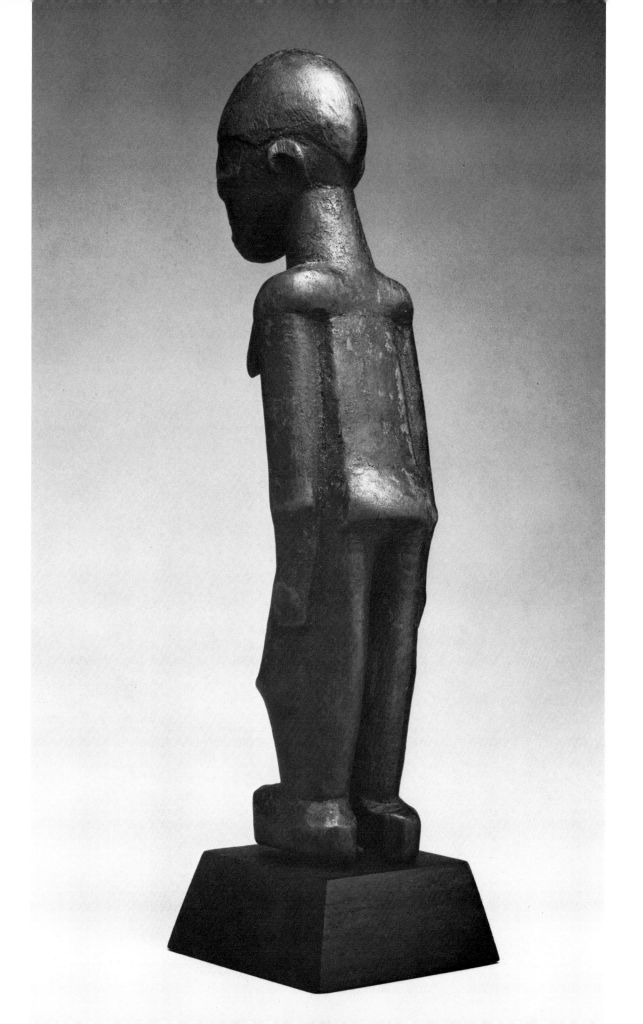

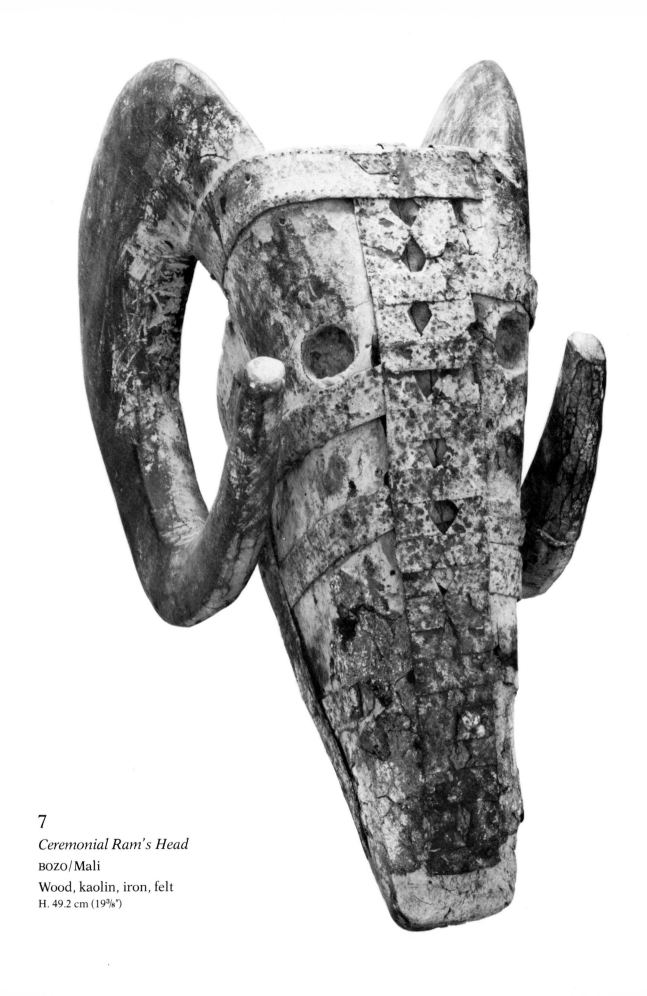

7

Ceremonial Ram's Head

BOZO / Mali

Wood, kaolin, iron, felt

H. 49.2 cm (19³⁄₈″)

Nigeria

8

Horse and Rider
YORUBA/Nigeria
Ivory
H. 19.1 cm (7½")

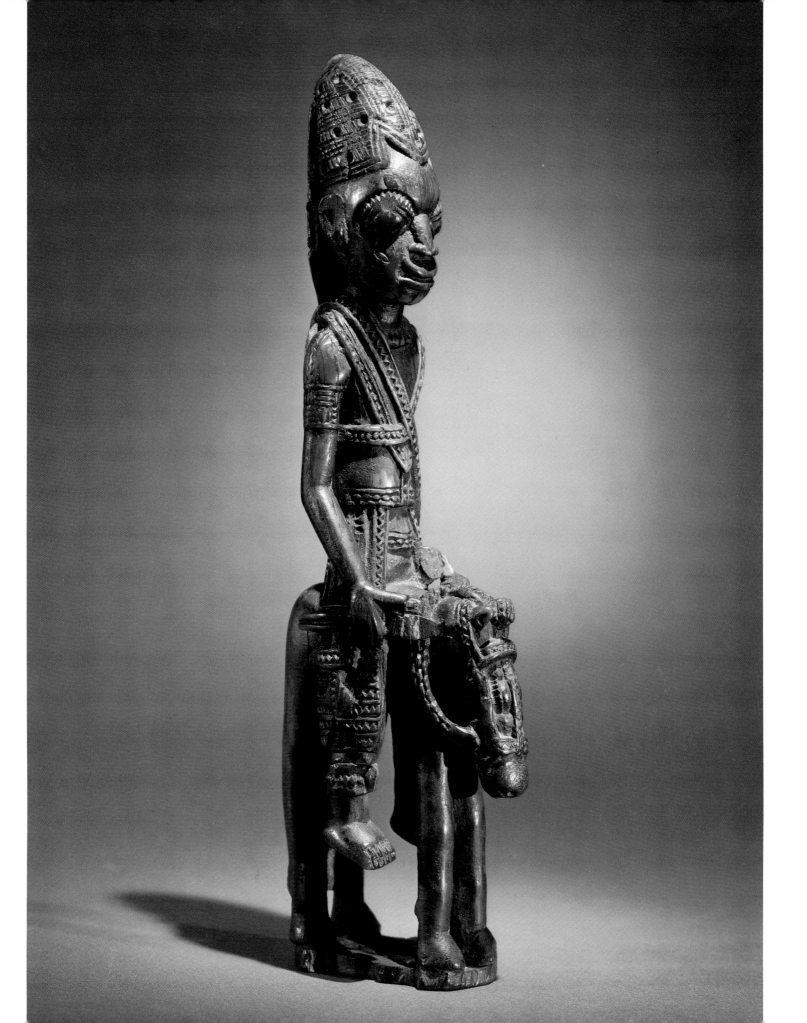

9
Gelede Mask
YORUBA/Nigeria
Wood, traces of pigment
L. 31.8 cm (12½″)

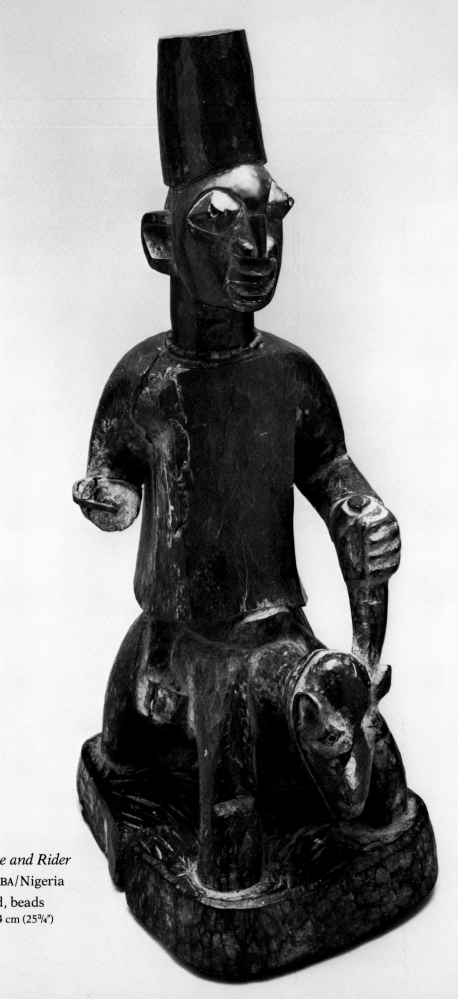

10
Horse and Rider
YORUBA/Nigeria
Wood, beads
H. 65.4 cm (25¾″)

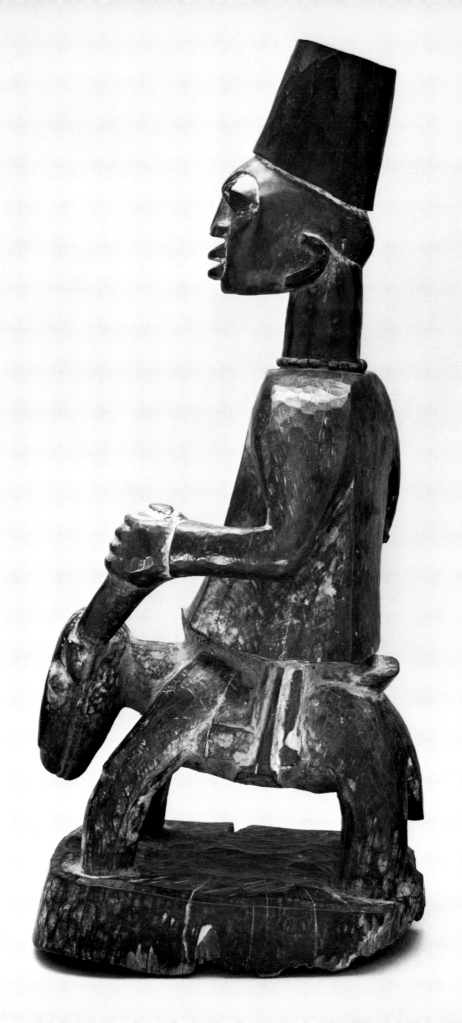

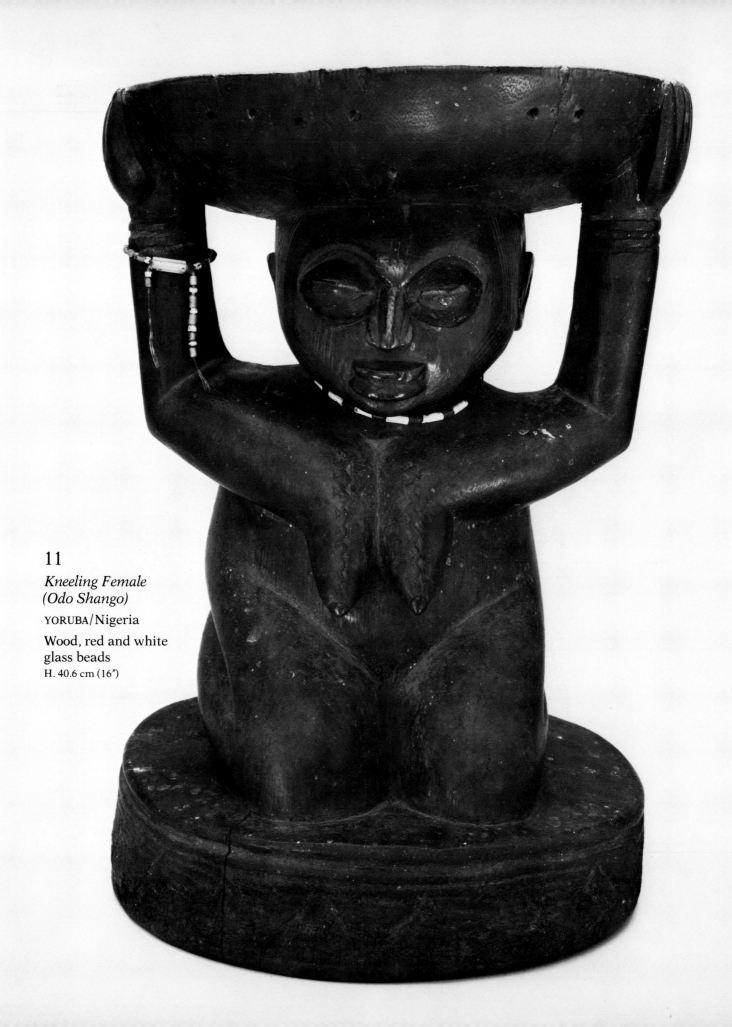

11
*Kneeling Female
(Odo Shango)*
YORUBA/Nigeria
Wood, red and white
glass beads
H. 40.6 cm (16″)

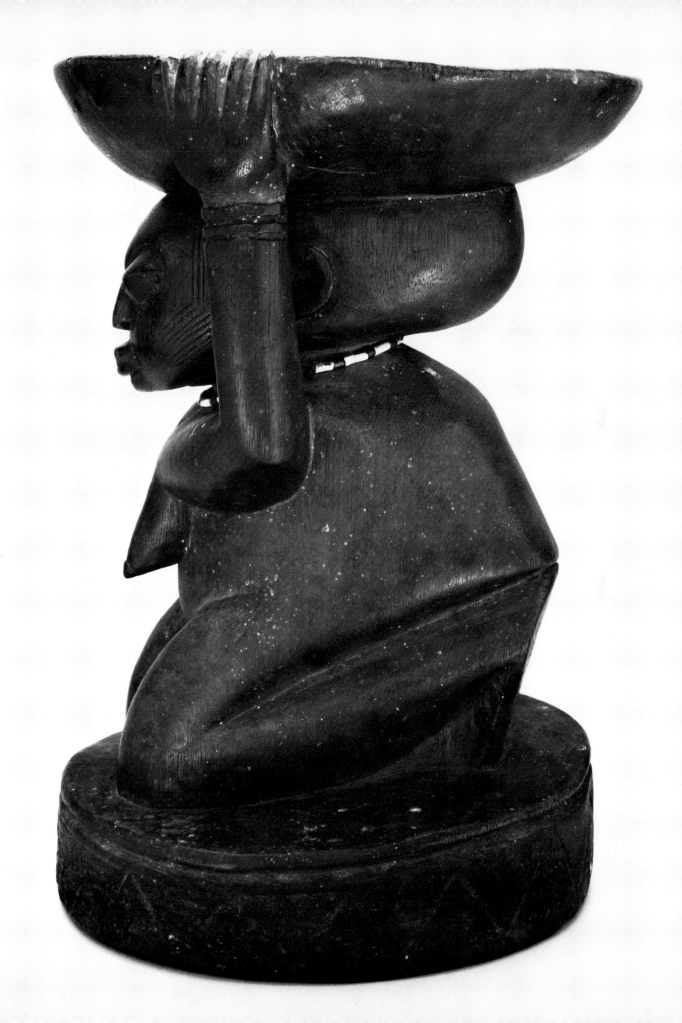

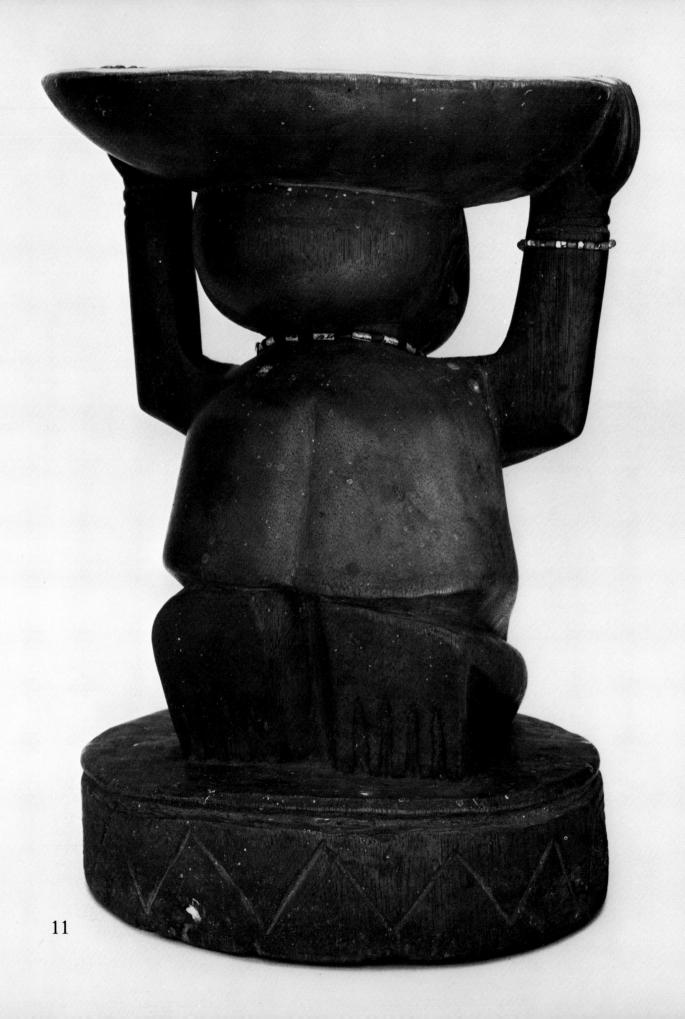

11

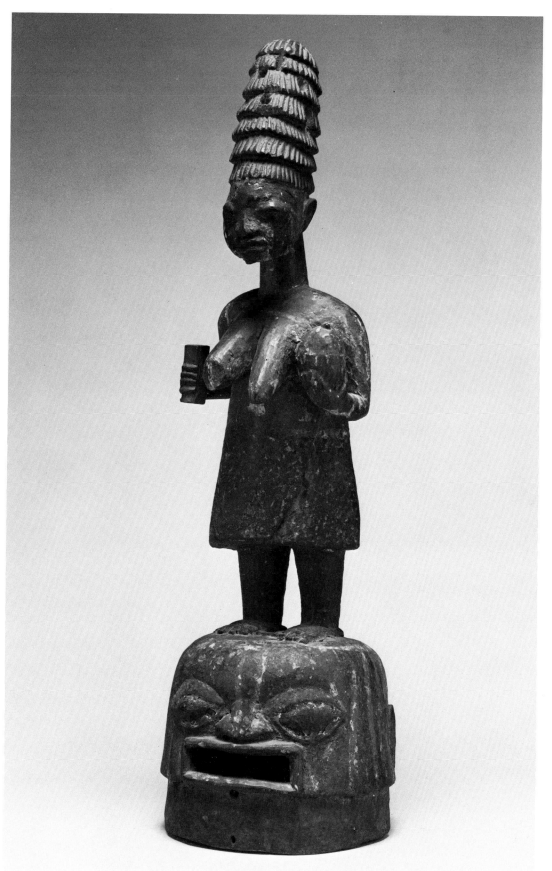

12
Epa Mask
YORUBA/Nigeria
Wood, paint
H. 82.2 cm (32³⁄₈″)

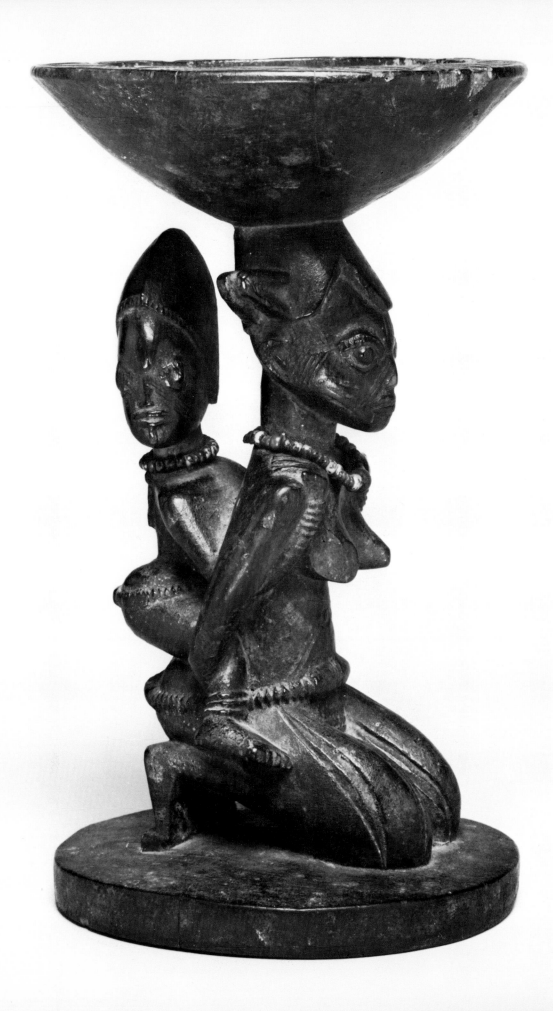

13
Divination Bowl:
Mother and Child
(Agere Ifa)

YORUBA/Nigeria

Wood, glass beads

H. 25.1 cm (9⁷/₈″)

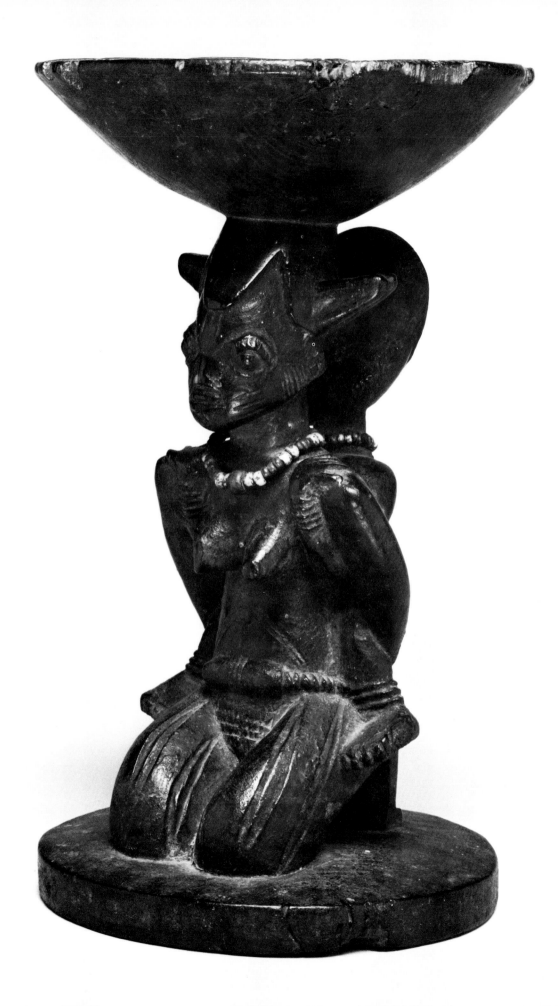

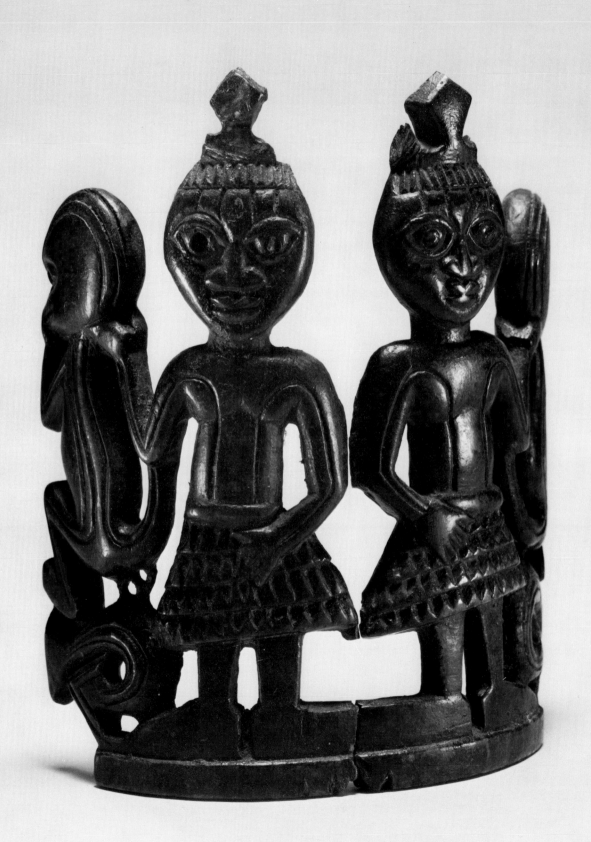

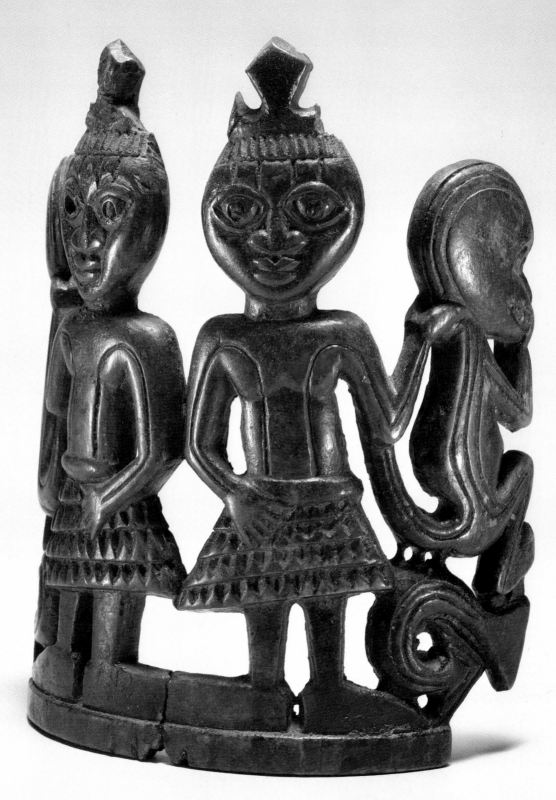

14
Royal Armlet
OWO, YORUBA
Nigeria
Ivory
H. 14 cm (5½″)

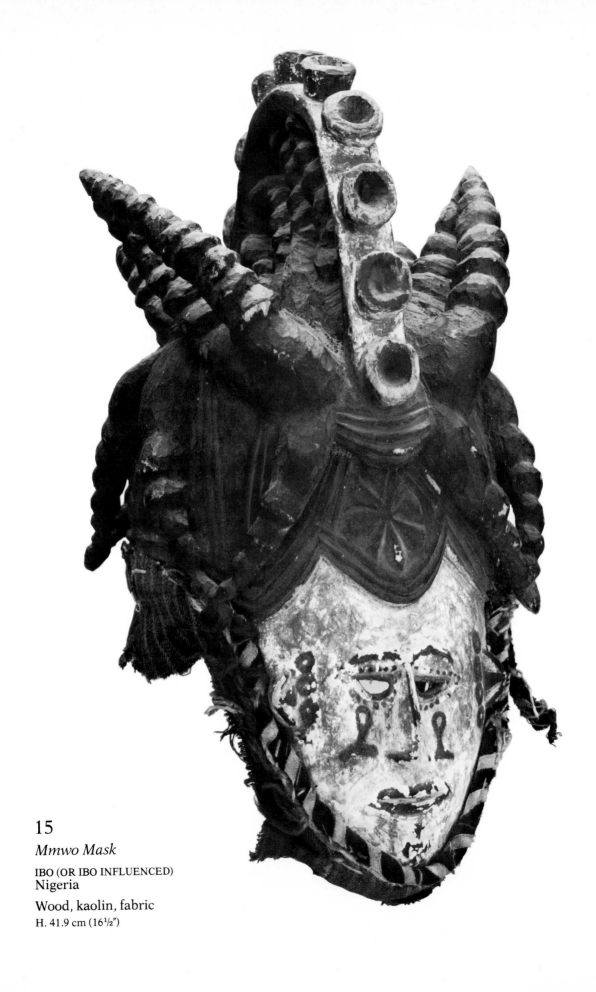

15

Mmwo Mask

IBO (OR IBO INFLUENCED)
Nigeria

Wood, kaolin, fabric
H. 41.9 cm (16½")

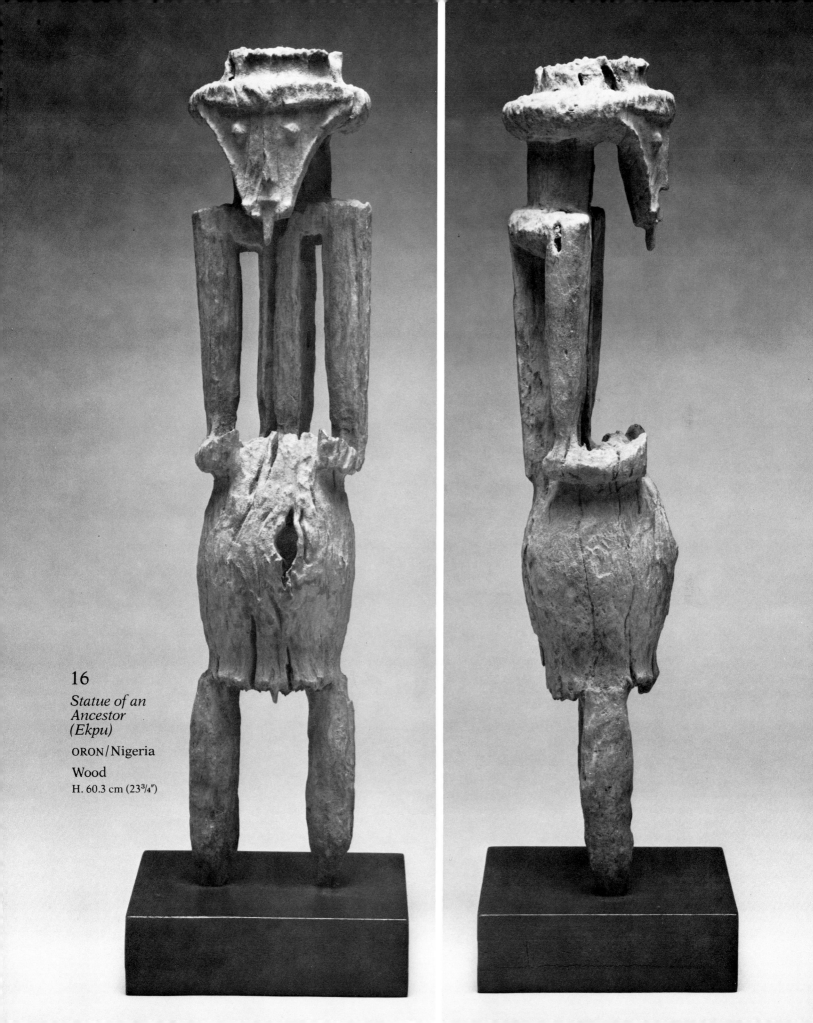

16
Statue of an
Ancestor
(Ekpu)
ORON/Nigeria

Wood

H. 60.3 cm (23¾")

17

Triple-Faced Helmet Mask

EKOI/Nigeria

Wood, painted skin, metal, bone

H. 45.7 cm (18″)

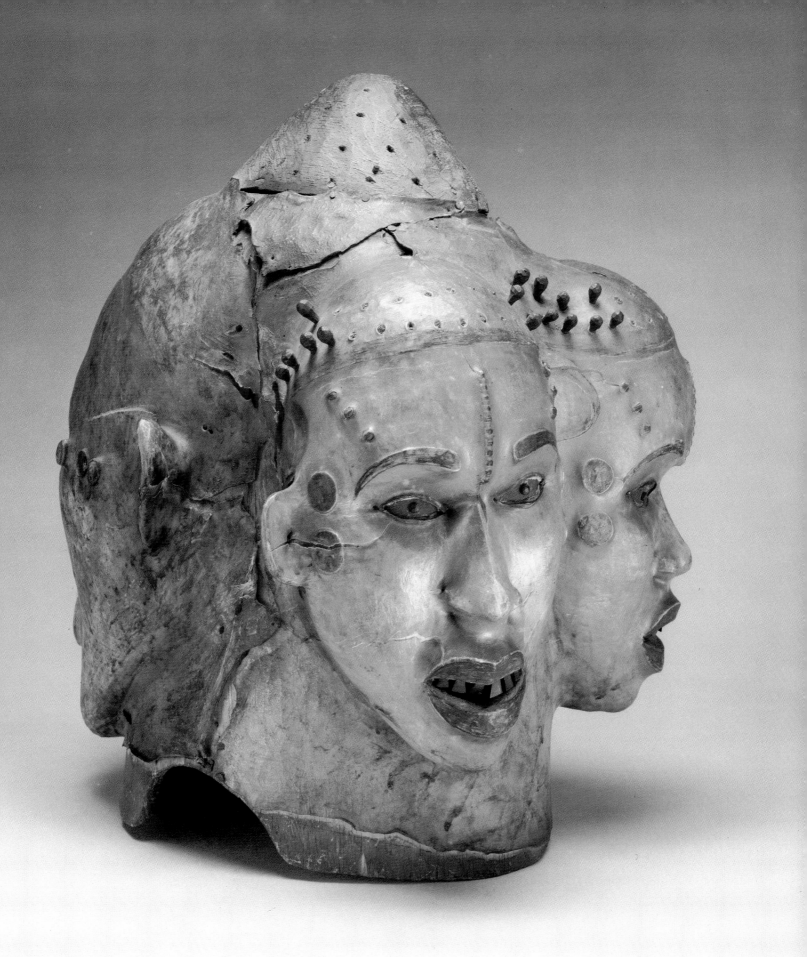

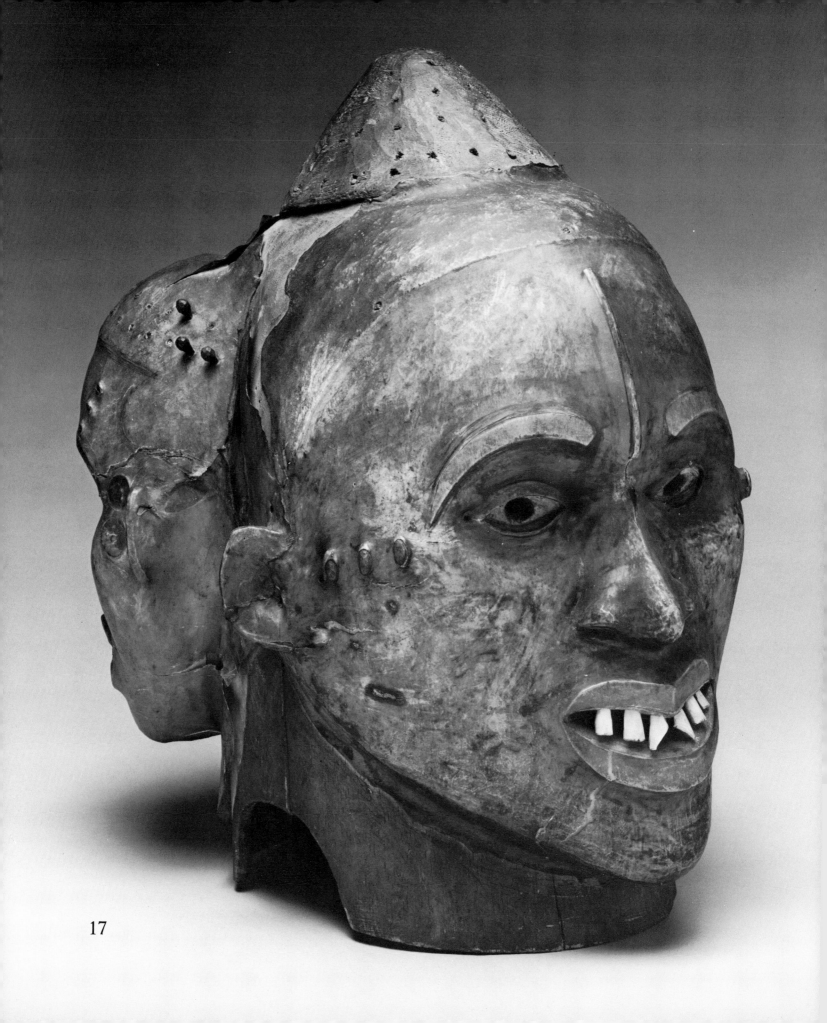

17

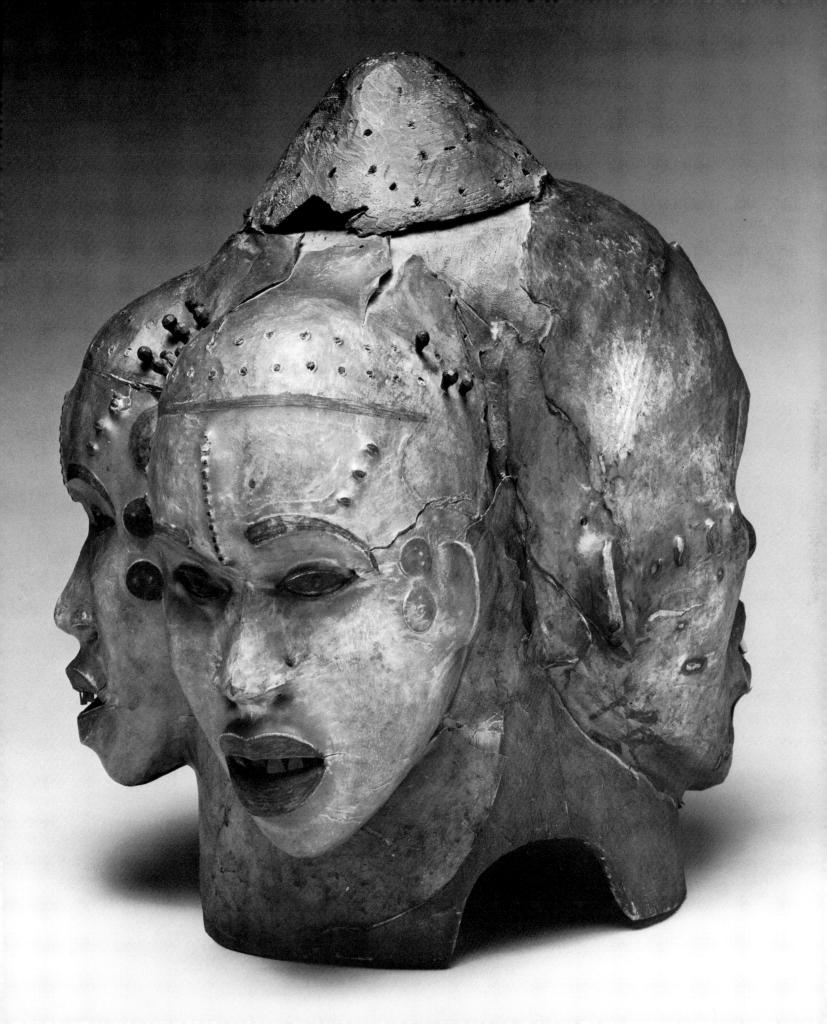

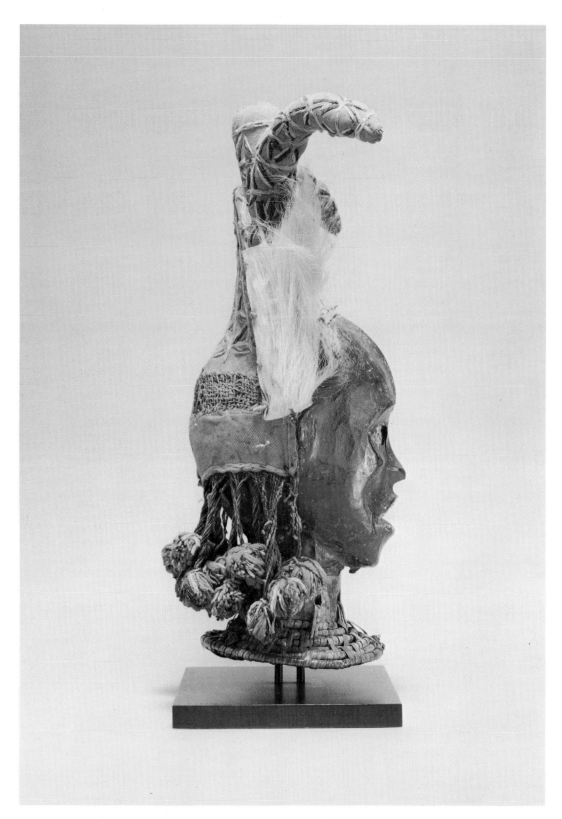

18

Mask

BOKYI/Nigeria

Wood, fabric, skin,
raffia, paint, horsehair
H. 39.4 cm (15½″)

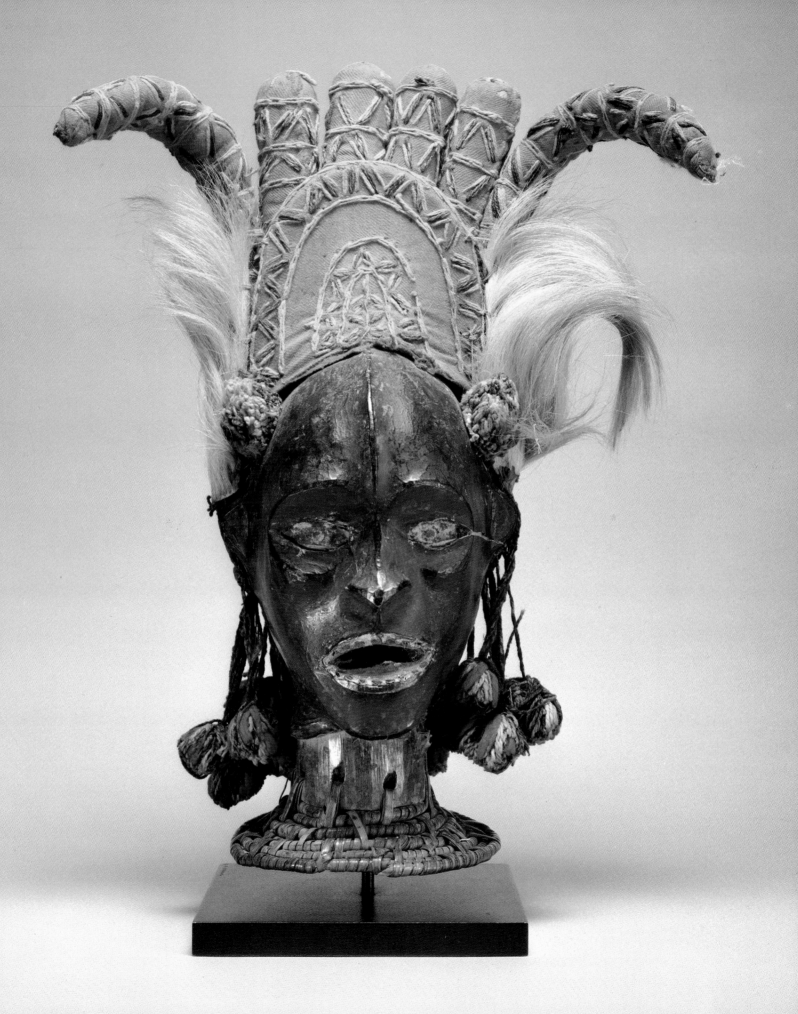

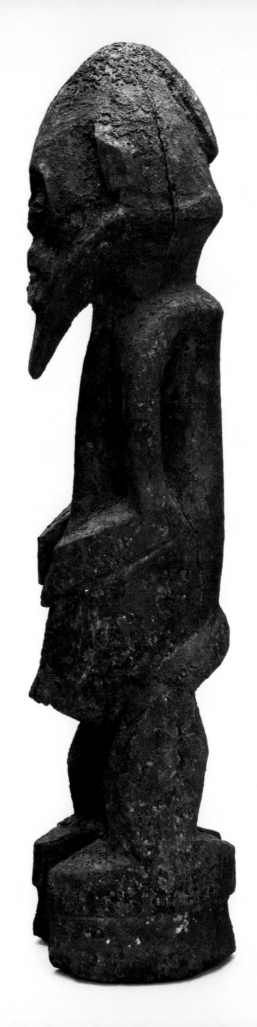

19
Standing Male Figure
KEAKA / Nigeria
Wood, encrustations
H. 52.1 cm (20½")

Cameroon

20

Door Frame (Detail)

BAMILEKE, KINGDOM OF BAHAM
Cameroon

Wood, traces of pigment

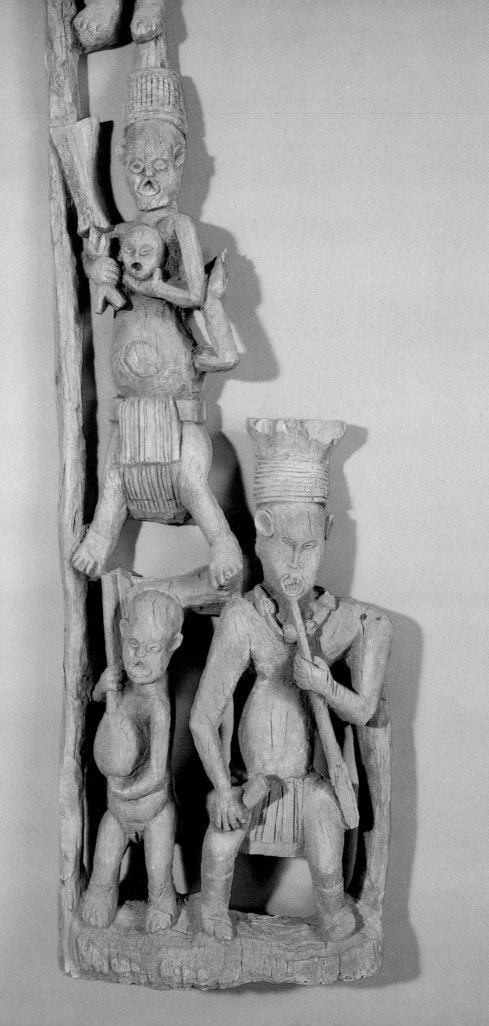

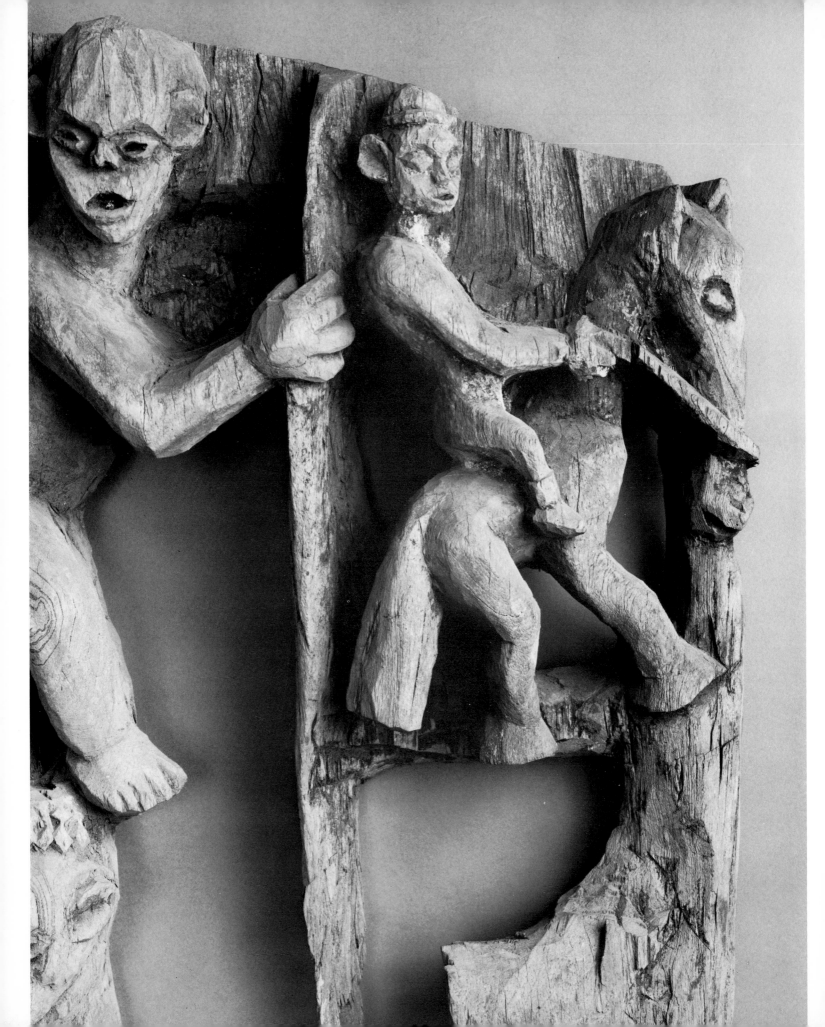

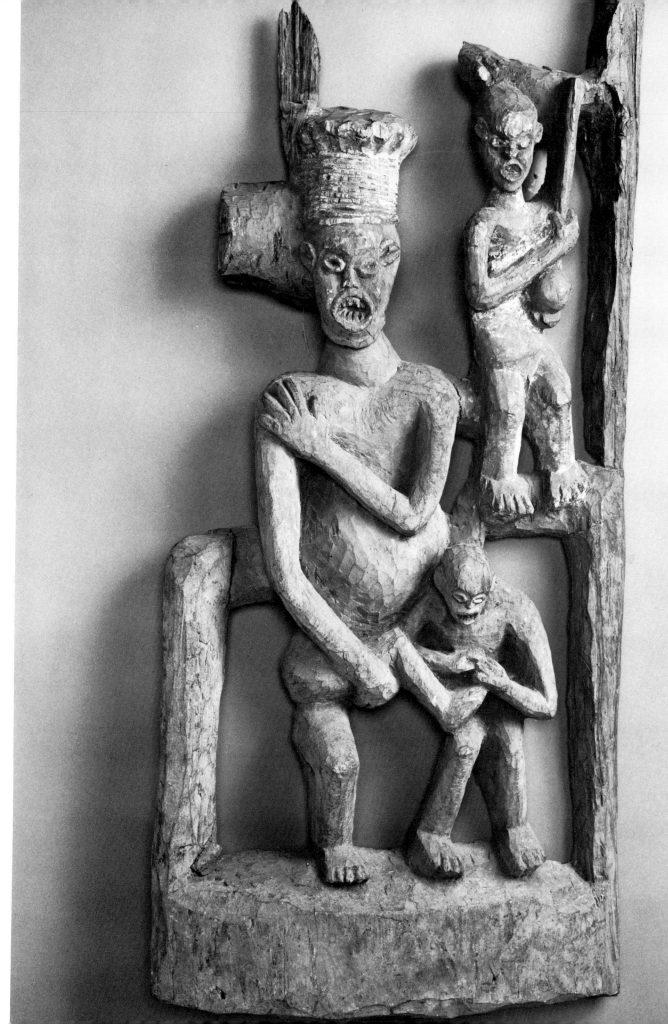

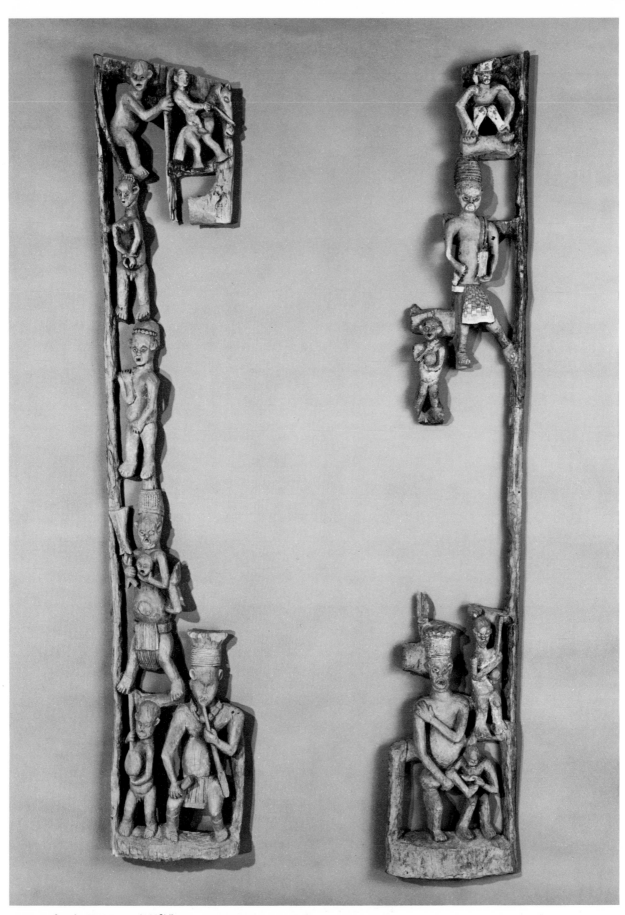

20 Left side: H. 256 cm (100¾")
Right side: H. 264.2 cm (104")

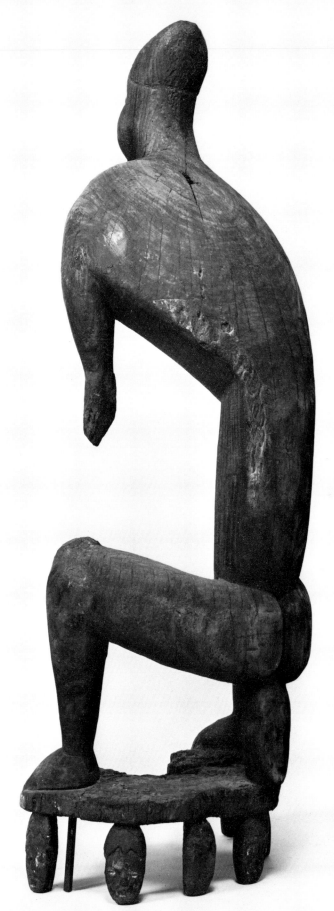

21
*Statue of King
Nguambo*

BAMILEKE, KINGDOM
OF BAKASSA
Cameroon

Wood
H. 157.5 cm (62″)

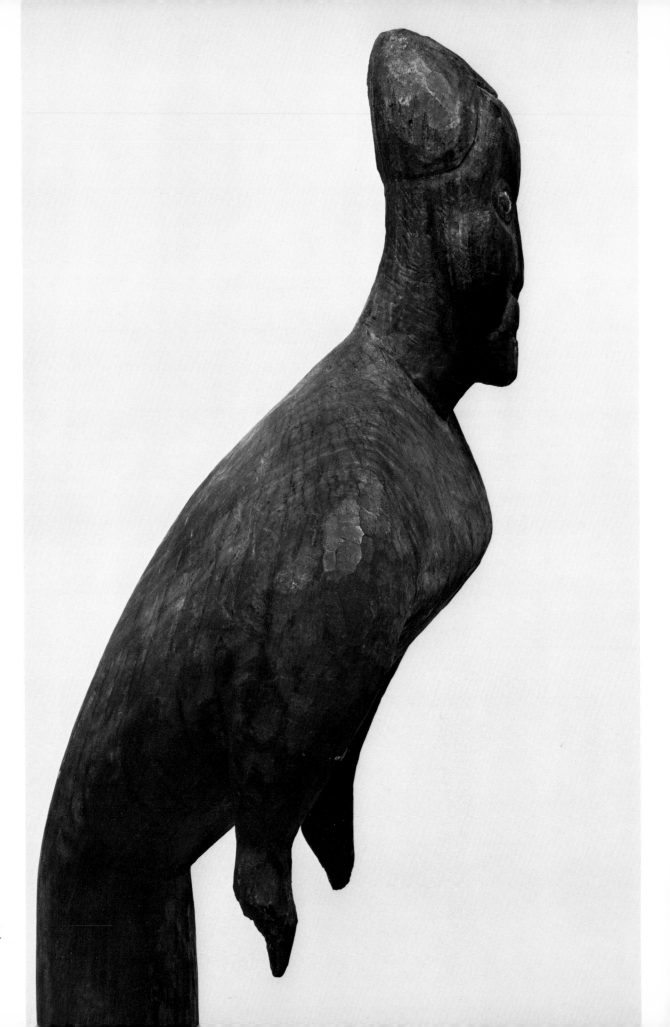

21

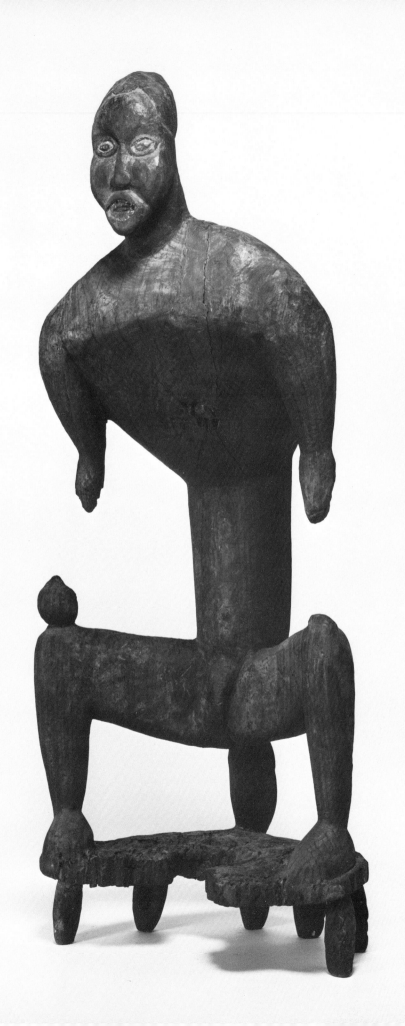

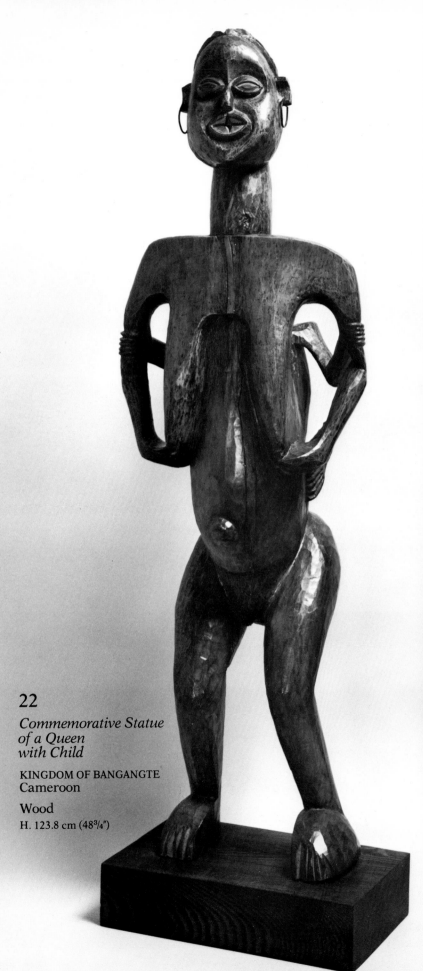
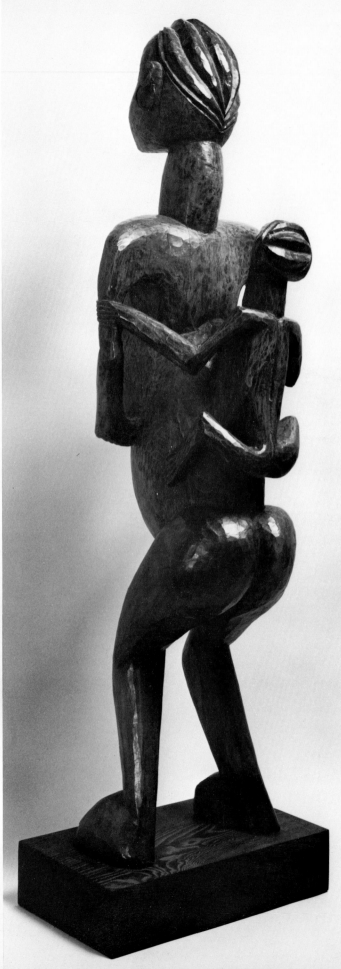

22
*Commemorative Statue
of a Queen
with Child*

KINGDOM OF BANGANGTE
Cameroon

Wood
H. 123.8 cm (48¾")

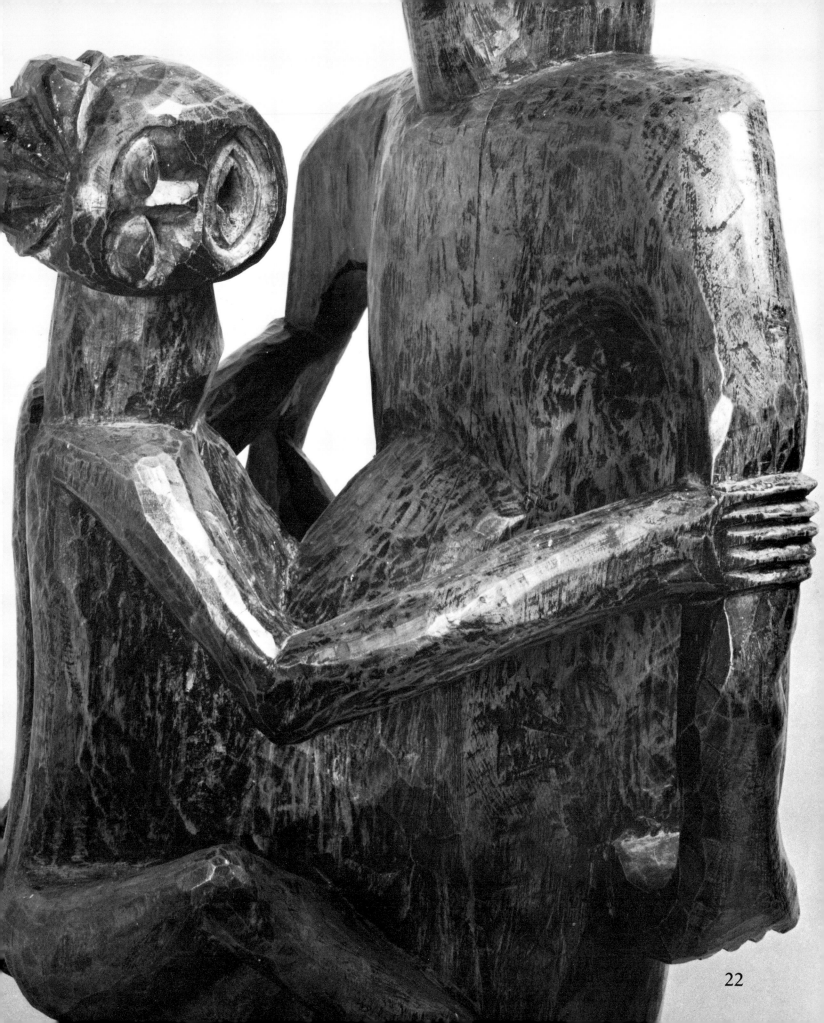

22

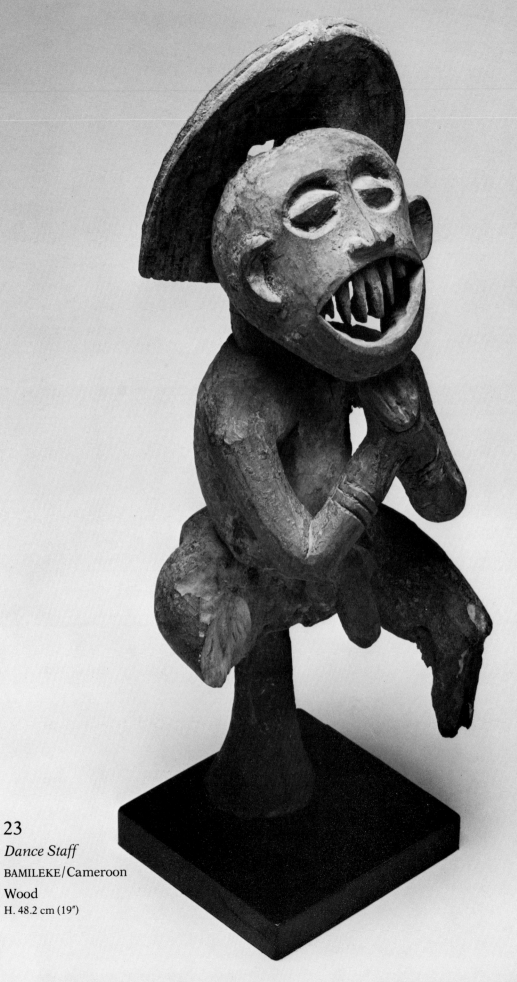

23
Dance Staff
BAMILEKE/Cameroon
Wood
H. 48.2 cm (19″)

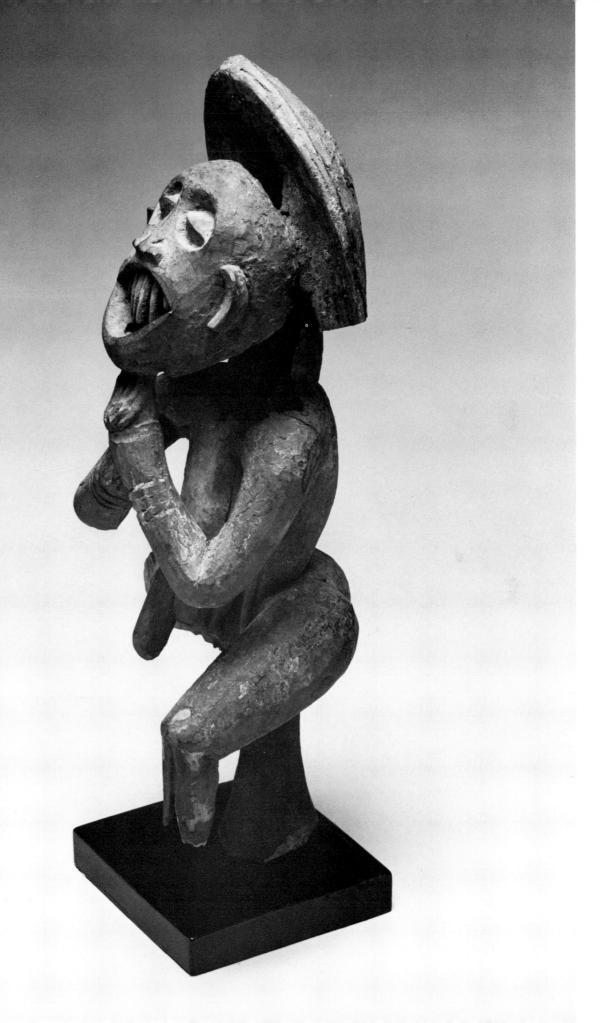

24

Post with Four Heads

BANGWA/Cameroon

Wood, encrustations

H. 118.7 cm (46¾″)

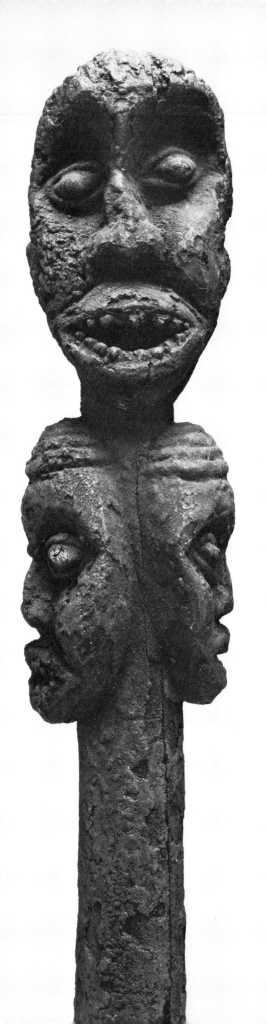

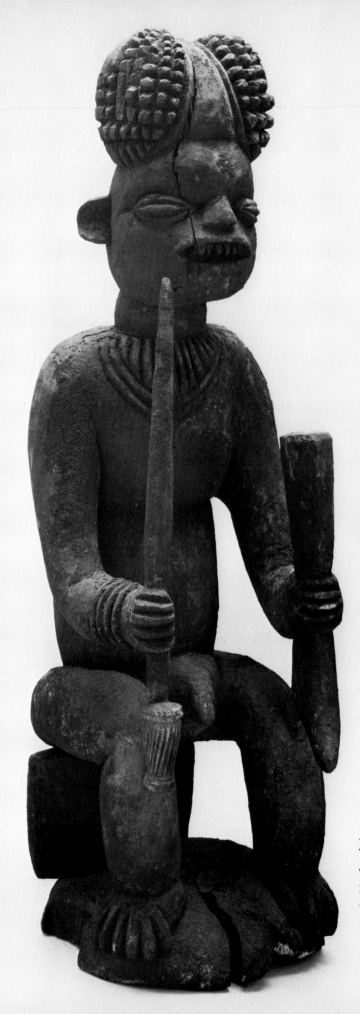

25
Statue of a King
BANGWA/Cameroon
Wood
H. 90.8 cm (35³/₄")

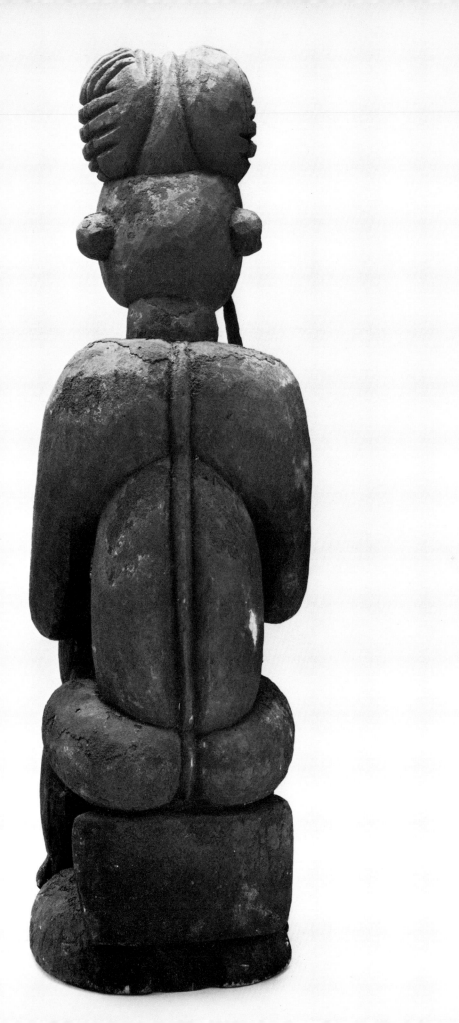

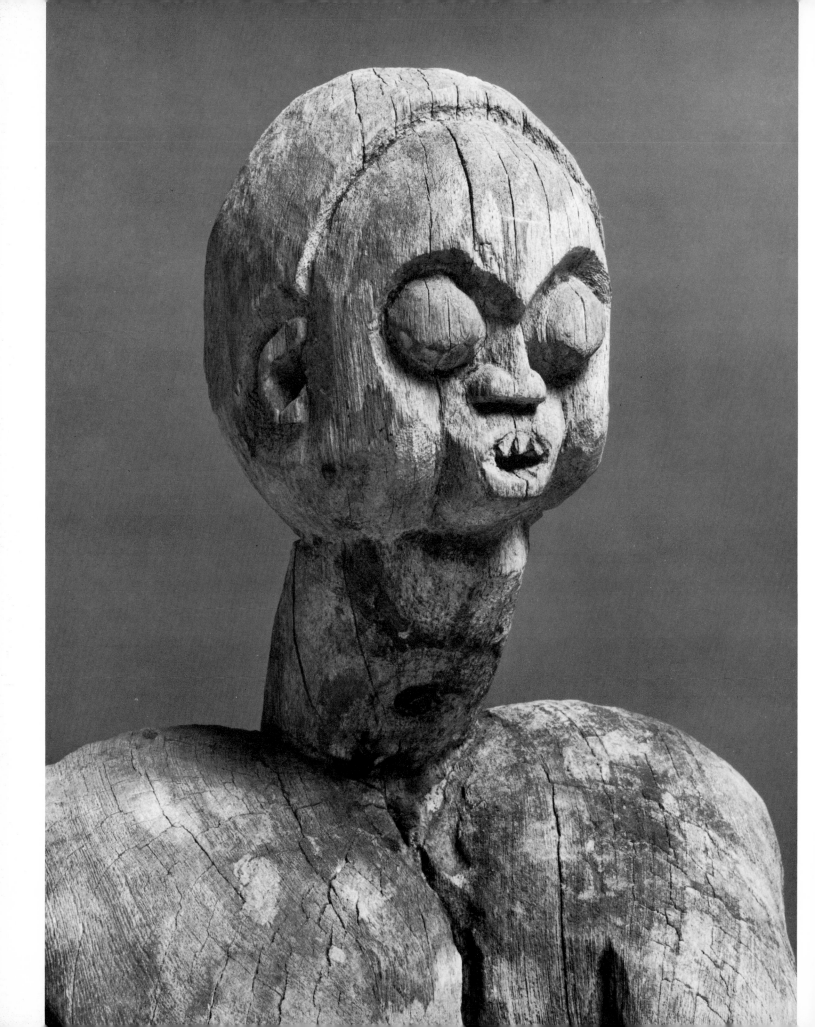

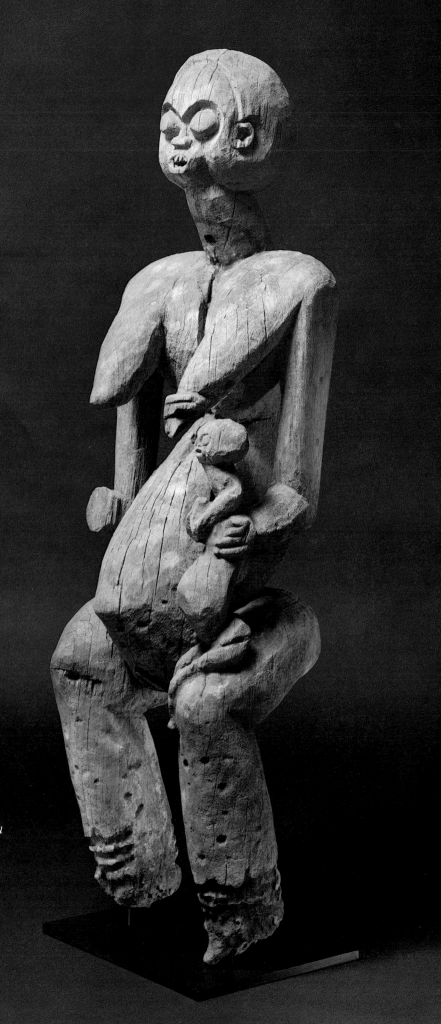

26
Statue of Queen Nana with Child

KINGDOM OF BATUFAM,
BANGWA
Cameroon

Wood with ochre
pigment
H. 101.3 cm (39⅞")

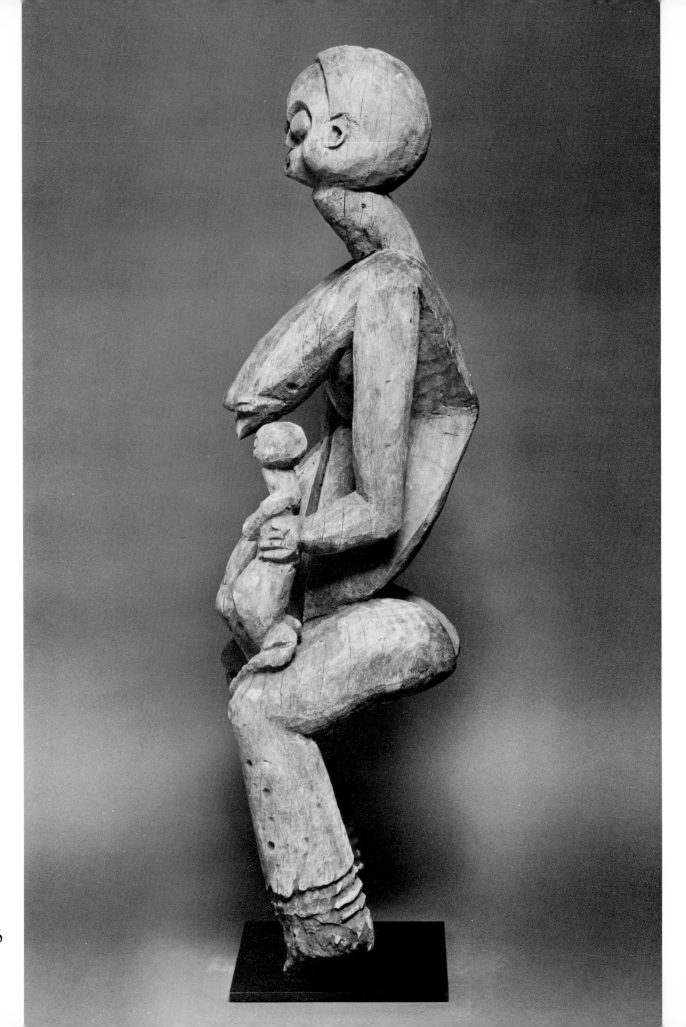

26

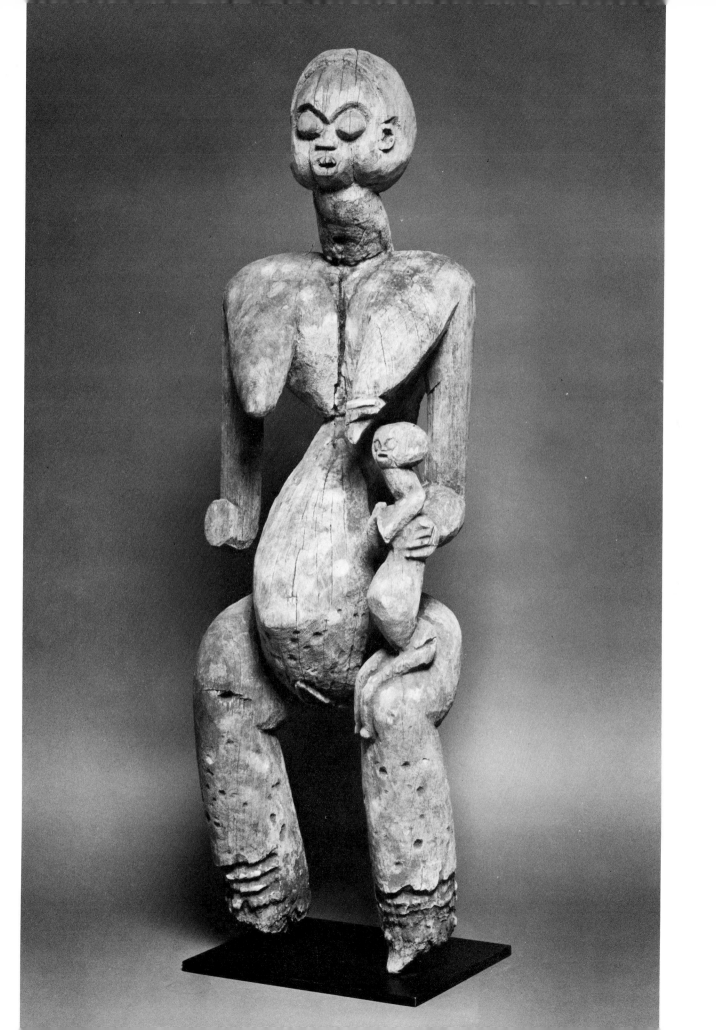

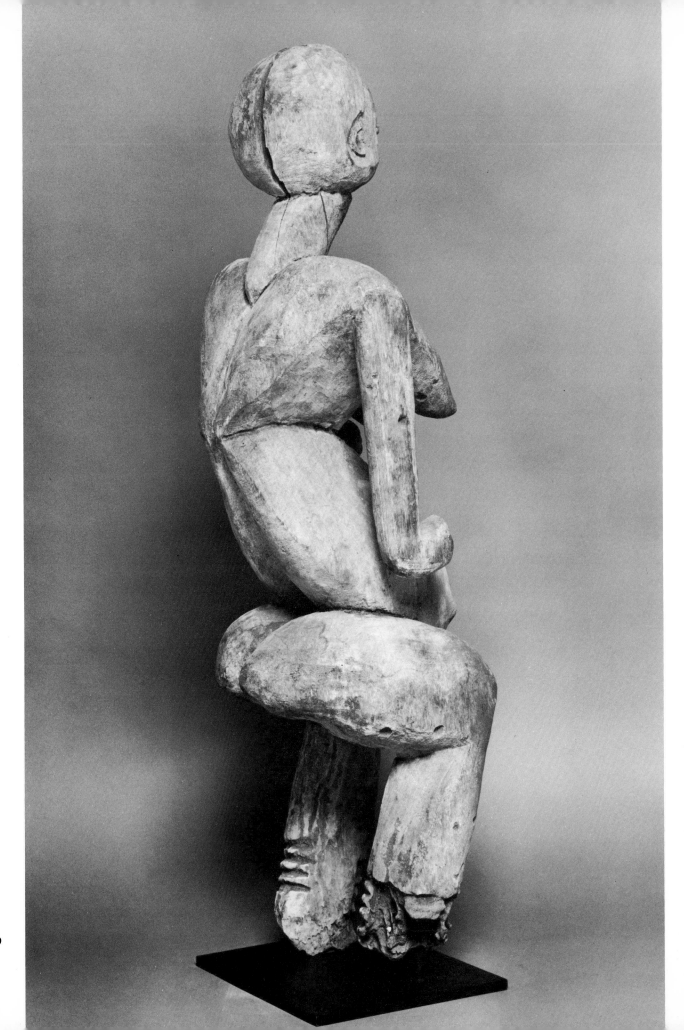

26

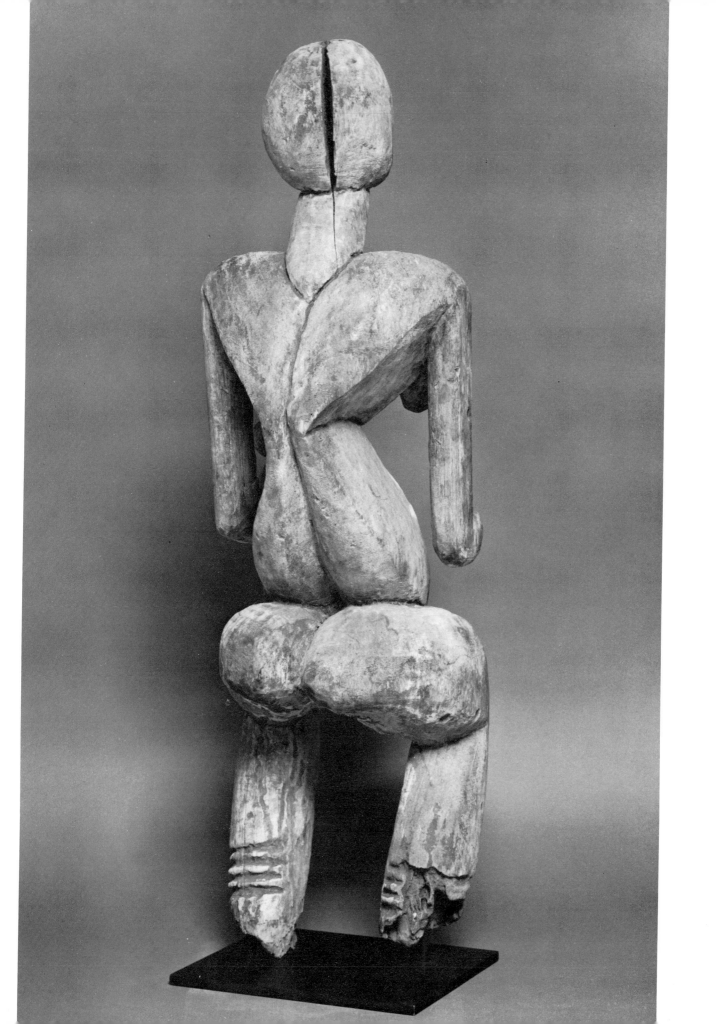

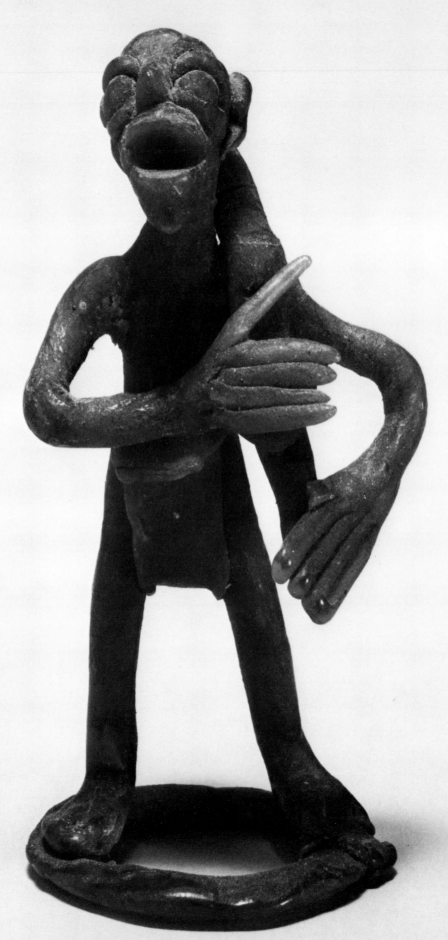

27
*Wax Figurine for
Metal Casting*
BAMUM/Cameroon

Beeswax
H. 7.3 cm (2⁷⁄₈")

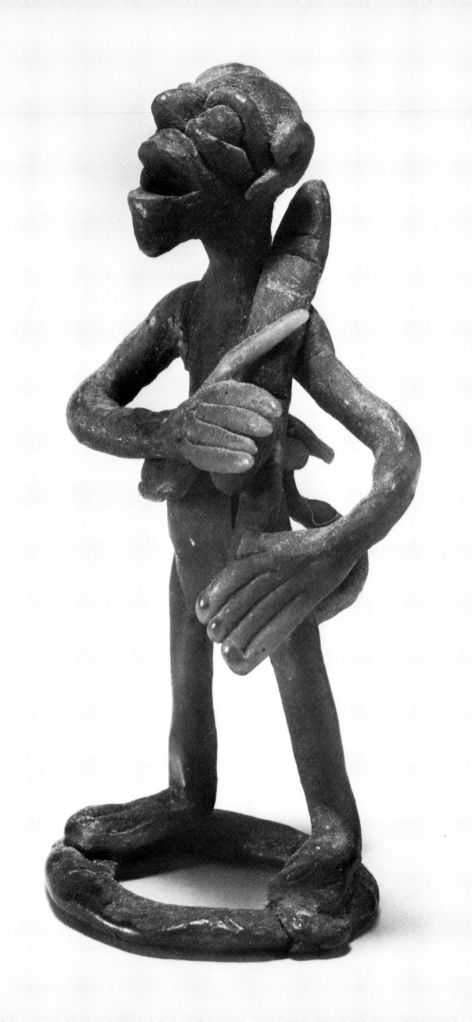

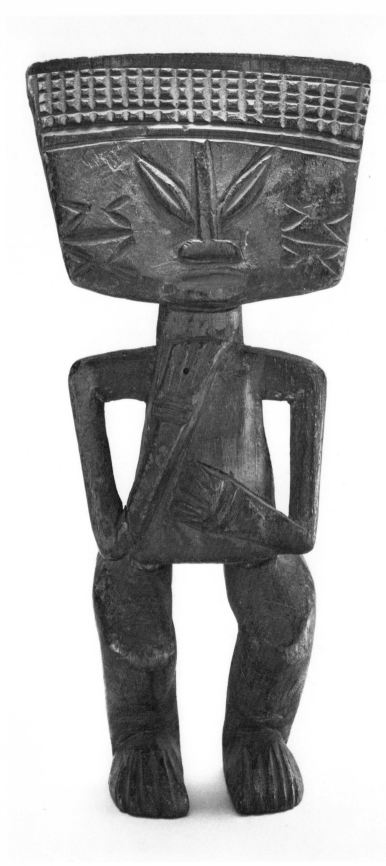
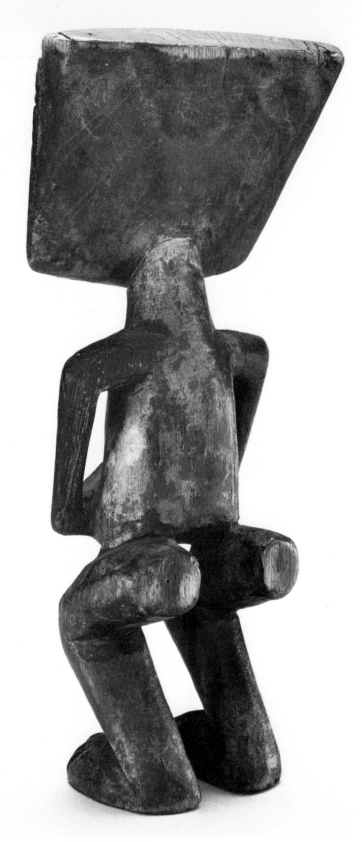

28 *Standing Male Figure*
BAMENDA/Cameroon
Wood
H. 23.5 cm (9¼″)

Gabon

29

Reliquary Figure

KOTA/Gabon

Wood, iron, brass, copper

H. 53 cm (20$\frac{7}{8}$")

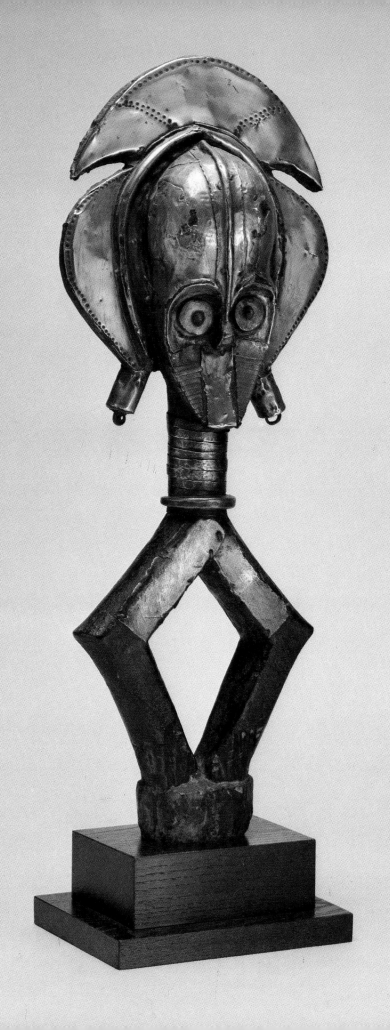

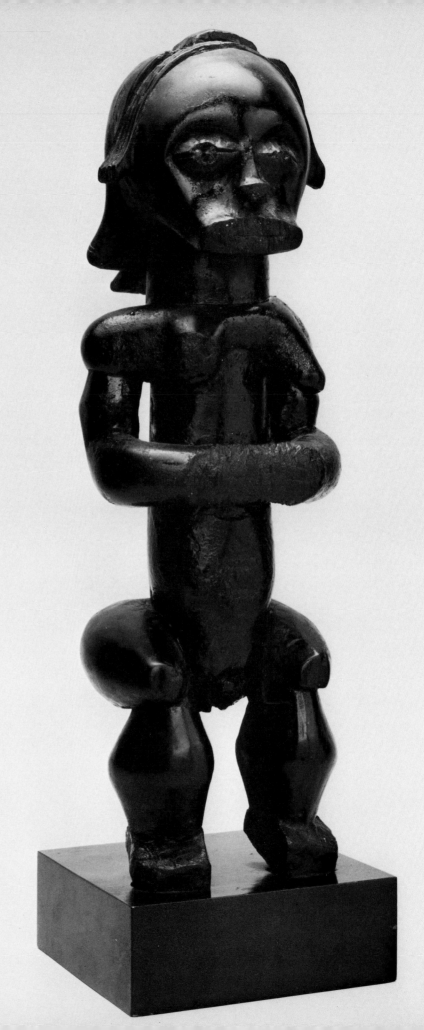

30
*Reliquary Figure
(Byeri)*
FANG/Gabon
Wood, palm oil
H. 40 cm (15³/₄″)

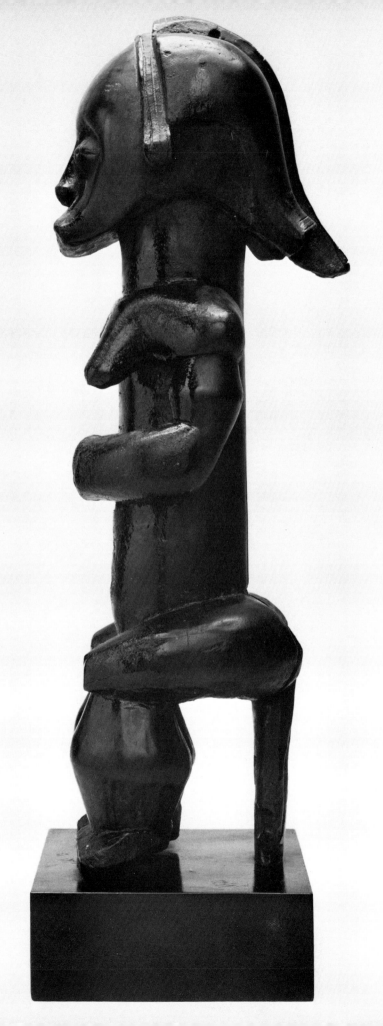

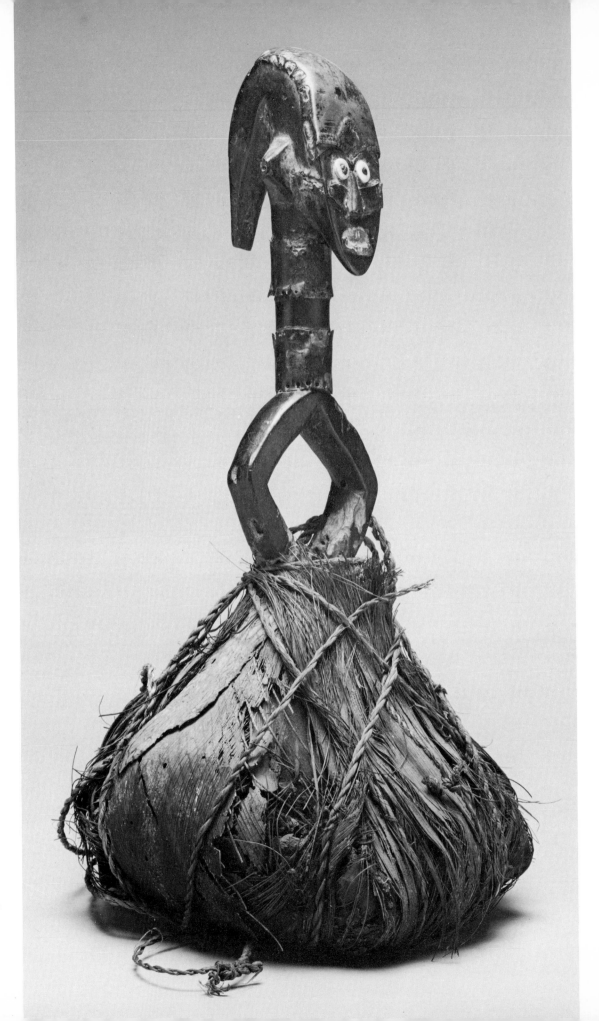

31
Reliquary Figure with Basket
KOTA/Gabon
Wood, metal, bone, fibre
H. 43.8 cm (17¼")

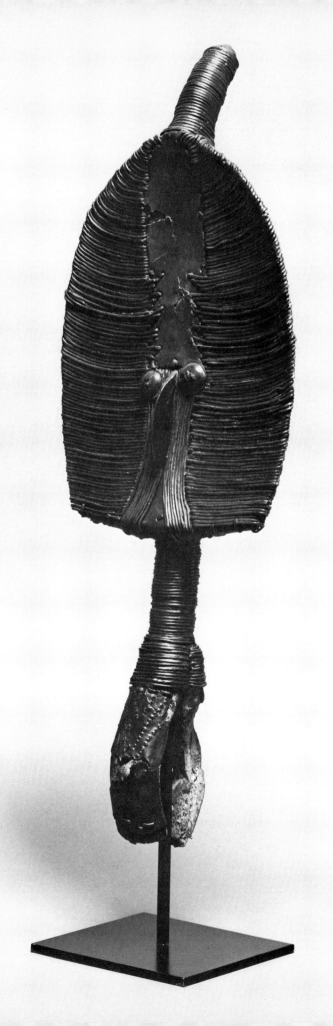

32
Reliquary Figure (Bwete)
MAHONGWE, KOTA/Gabon
Wood, corroded brass,
copper, iron
H. 55.9 cm (22″)

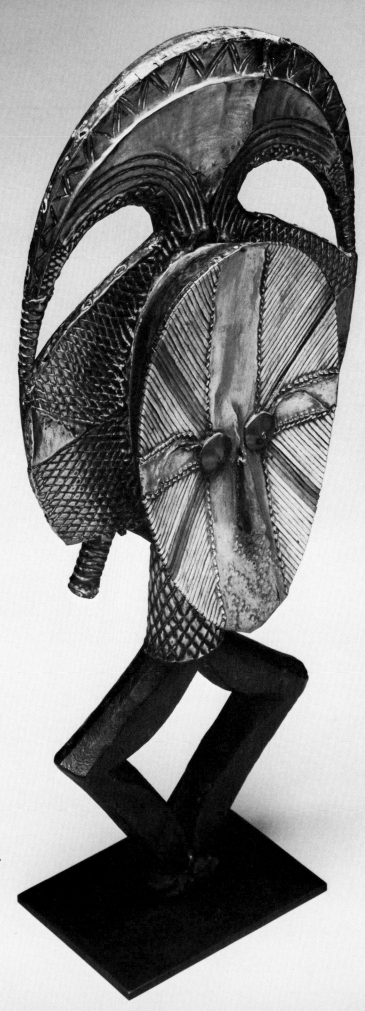

33
Reliquary Figure
KOTA/Gabon
Wood, brass, copper,
iron
H. 50.1 cm (19¾")

Congo

34
Royal Sceptre
YOMBE, KONGO/Zaïre
Wood, beads
H. 85.7 cm (33³/₄")

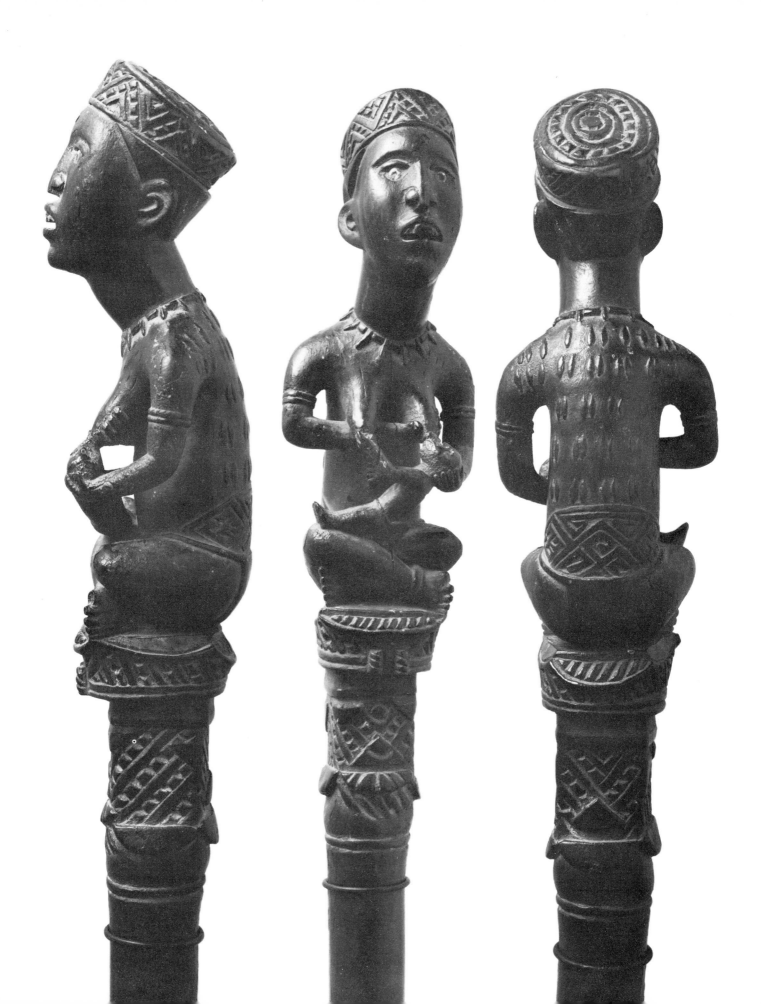

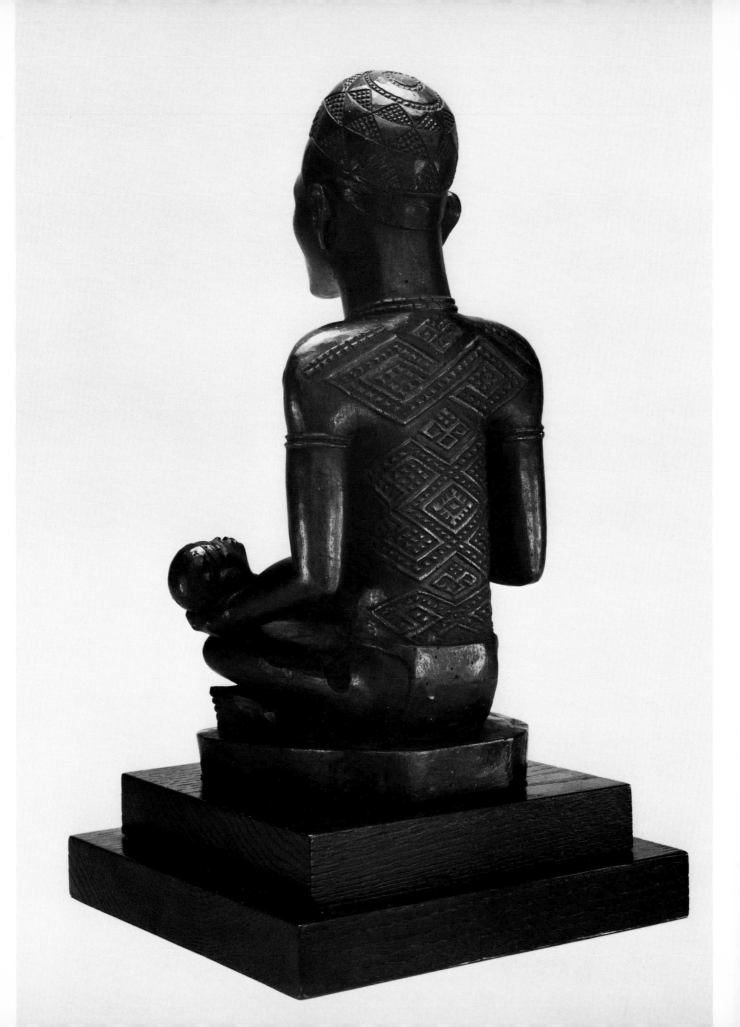

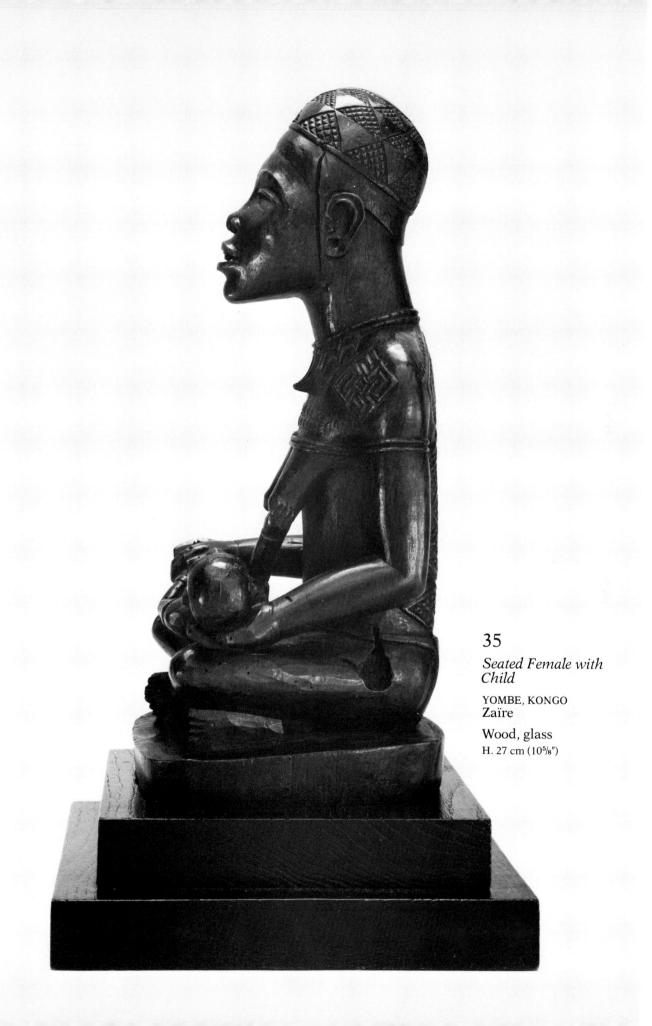

35
Seated Female with Child

YOMBE, KONGO
Zaïre

Wood, glass
H. 27 cm (10⅝")

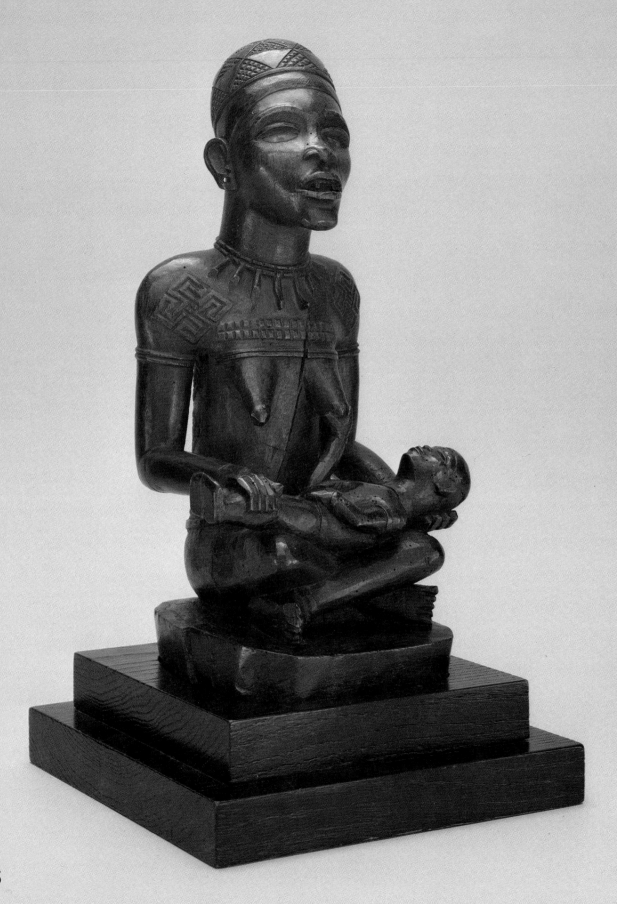

35

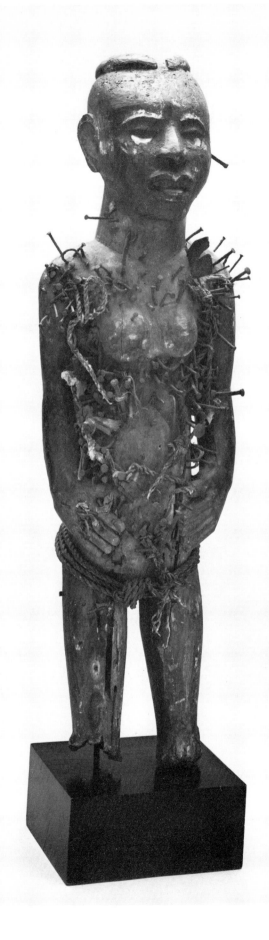

36
*Female Nail Fetish
(Nkondi)*

YOMBE, KONGO
Zaïre

Wood, traces of
kaolin, iron, fibre,
fabric, mirror
H. 74.9 cm (29½")

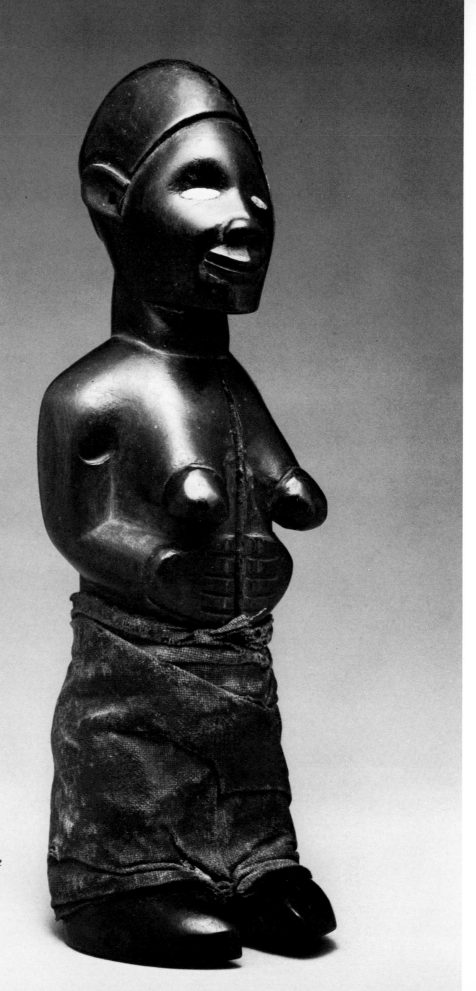

37
Female Figure
BEMBE, Zaïre
Wood, canvas
H. 16.5 cm (6½″)

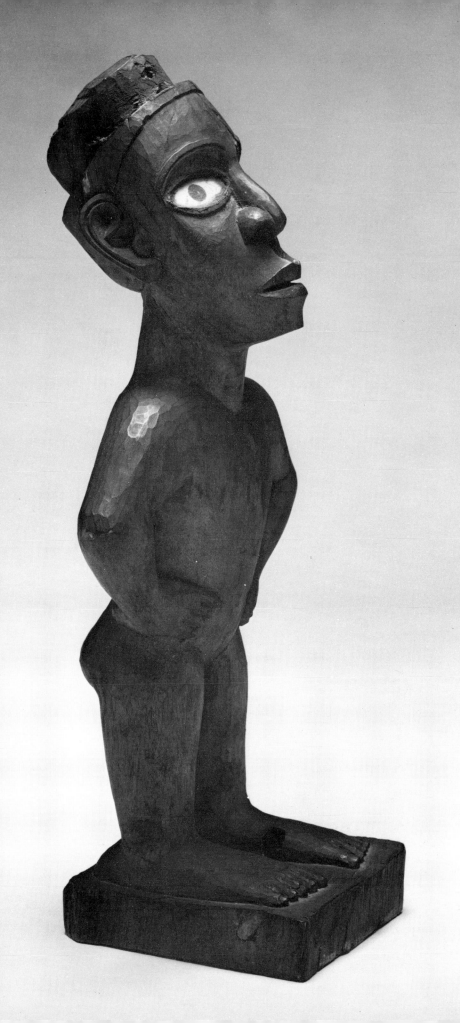

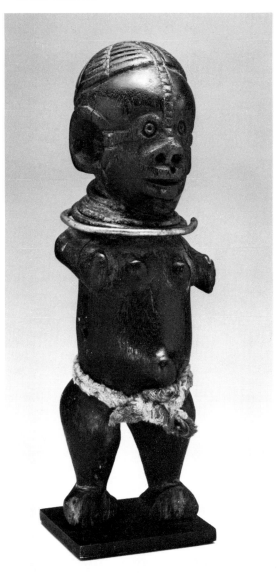

39
Female Figure
TABWA OR NGBAKA/Zaïre
Wood, brass, cloth, beads
H. 15.9 cm (6¼″)

38
Male Figure
KONGO/Zaïre
Wood, glass, paint
H. 33 cm (13″)

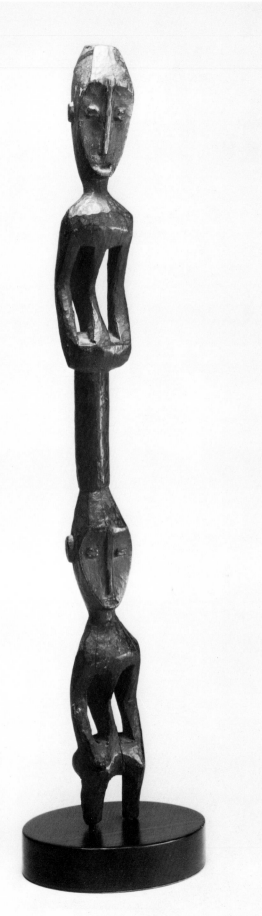

40
Staff
LENGOLA/Zaïre
Wood
H. 69.2 cm (27¹⁄₄″)

41
*Whistle: Crouching
Female Figure*
KONGO/Zaïre
Wood
H. 11.4 cm (4¹⁄₂″)

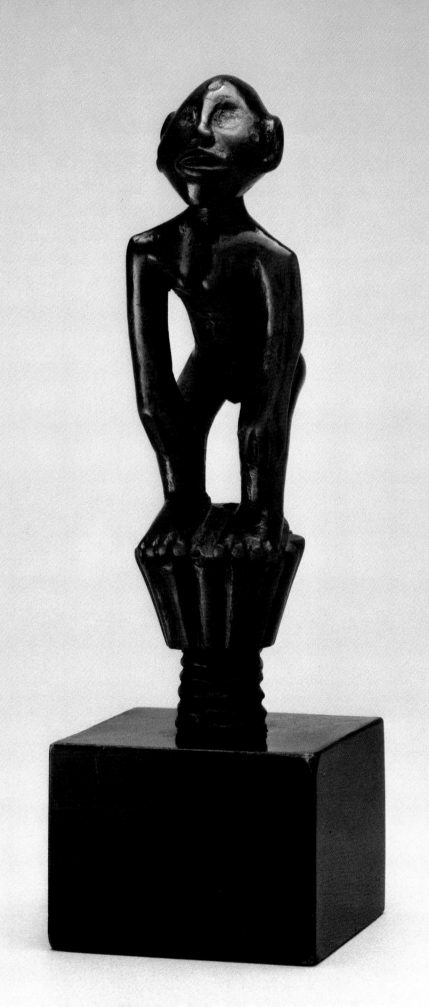

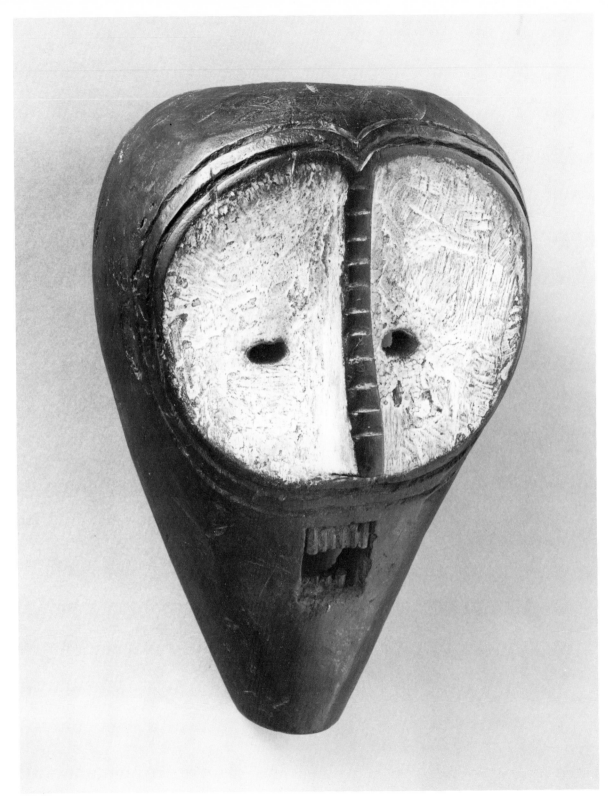

42
Mask
NGBAKA / Zaïre
Wood, kaolin
H. 24.1 cm (9½″)

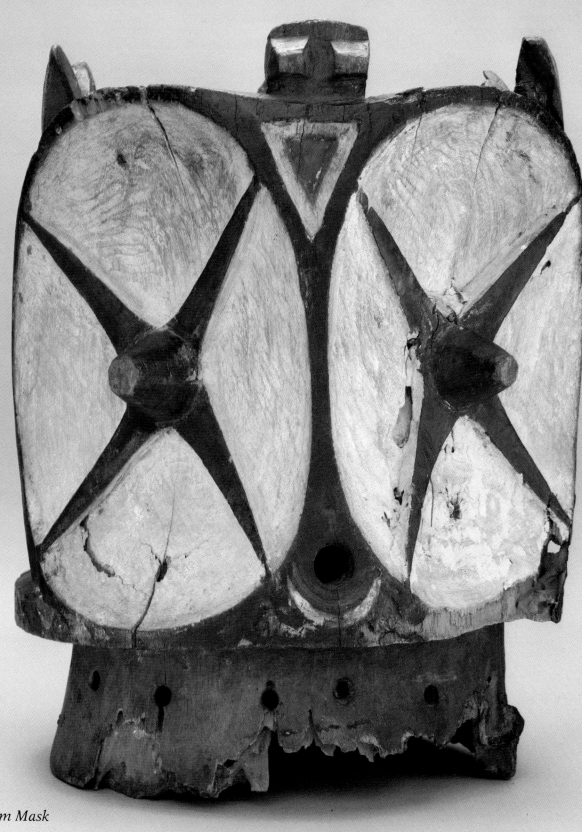

43

Alunga Janiform Mask

BEMBE/Zaïre

Wood, red, white and black pigment

H. 42.2 cm (16⁵/₈″)

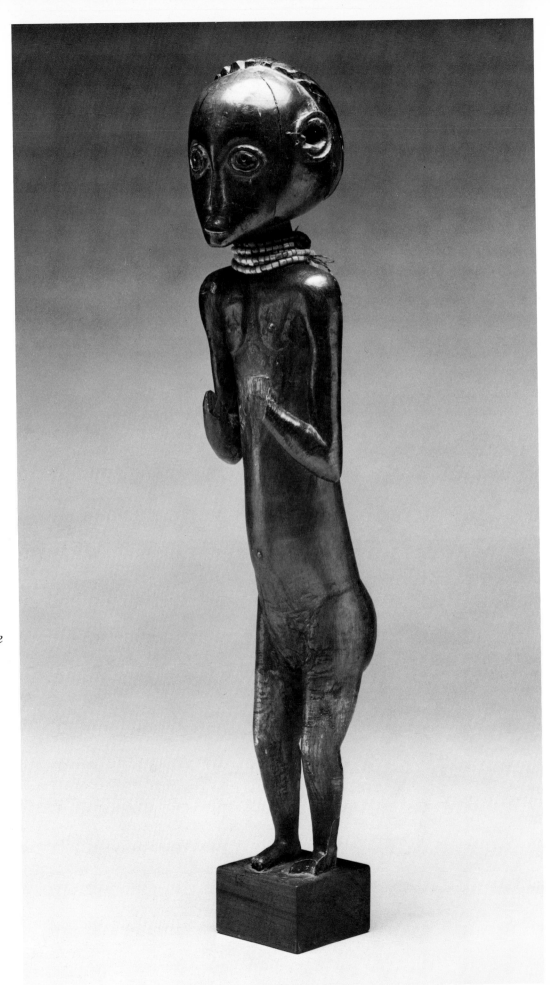

44
Standing Female Figure
OVIMBUNDU/Angola
Wood, beads
H. 44.5 cm (17½″)

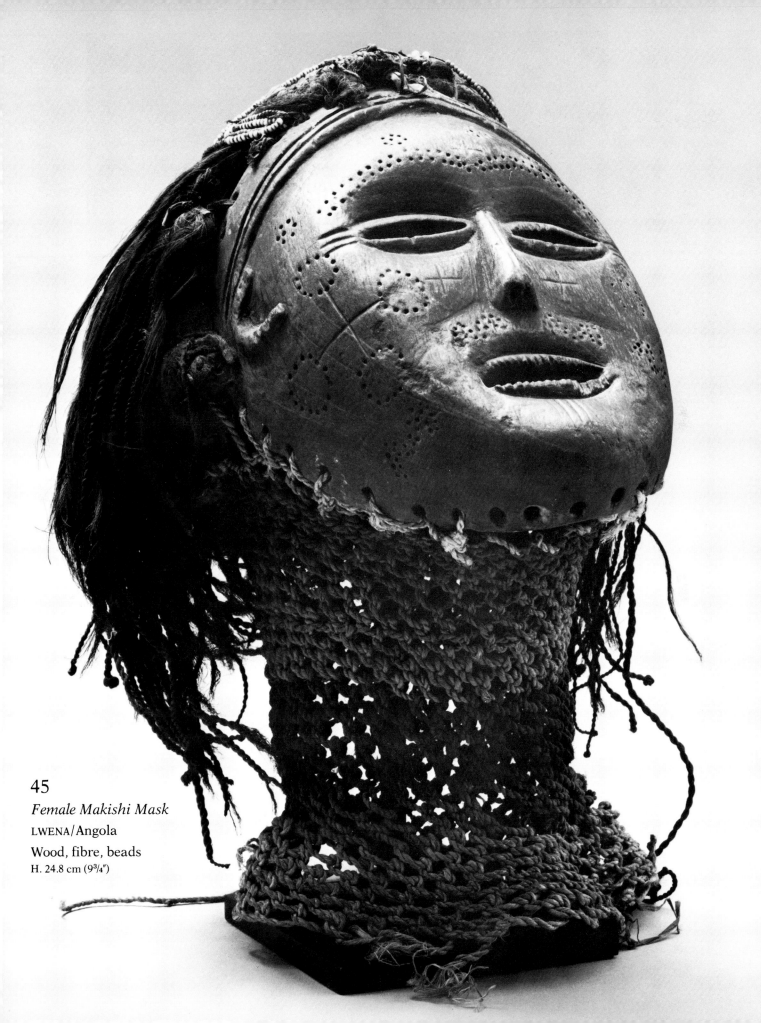

45
Female Makishi Mask
LWENA/Angola
Wood, fibre, beads
H. 24.8 cm (9¾″)

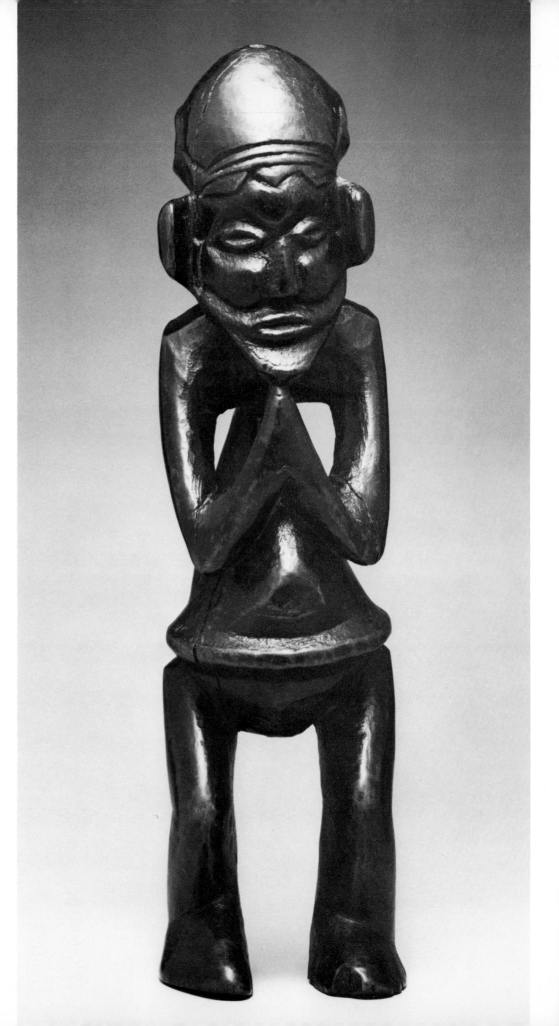

46
Standing Male Figure
SUKU / Zaïre

Wood
H. 23.8 cm (9³/₈″)

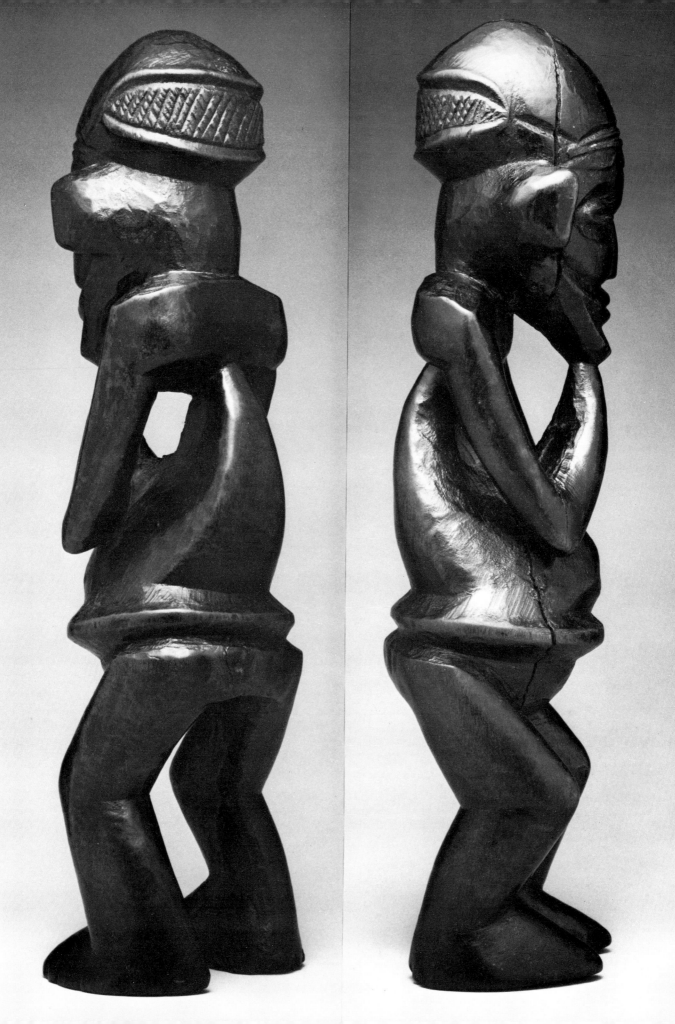

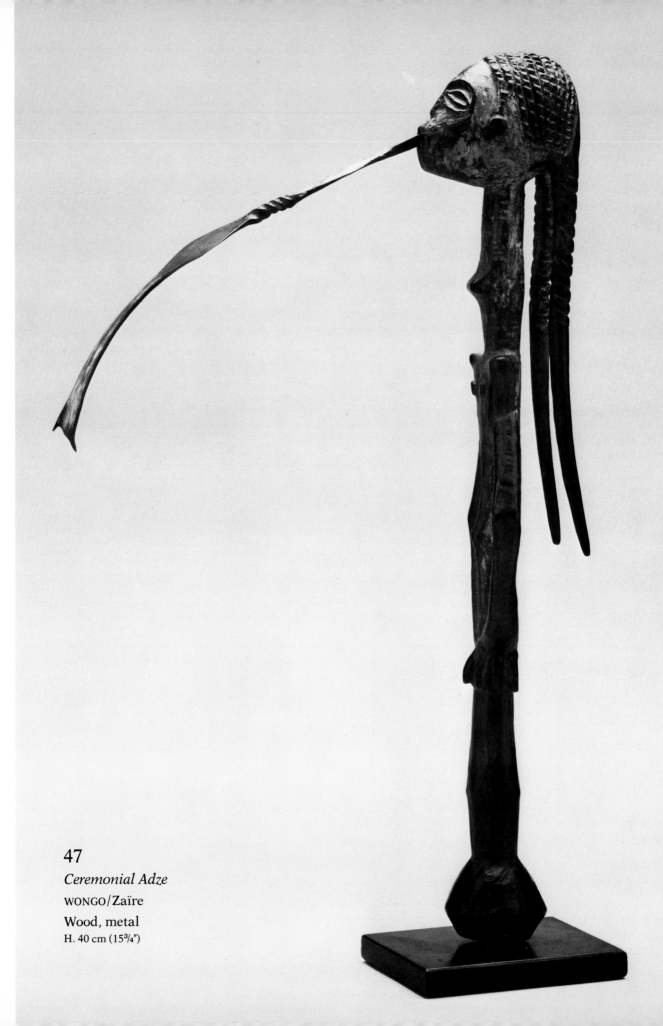

47
Ceremonial Adze
WONGO/Zaïre
Wood, metal
H. 40 cm (15¾")

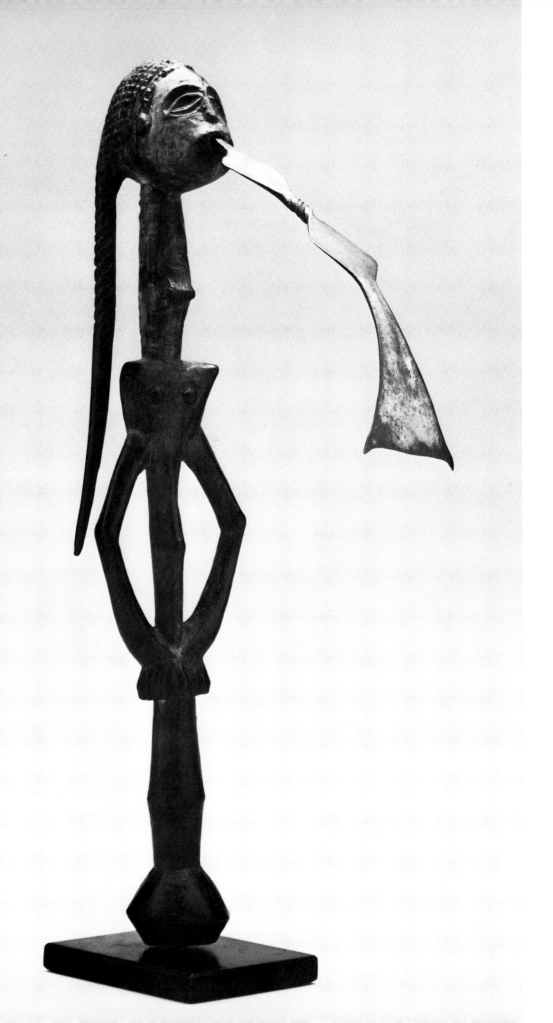

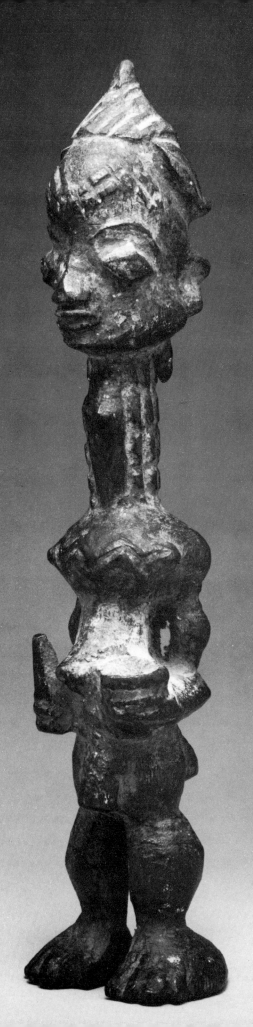

48

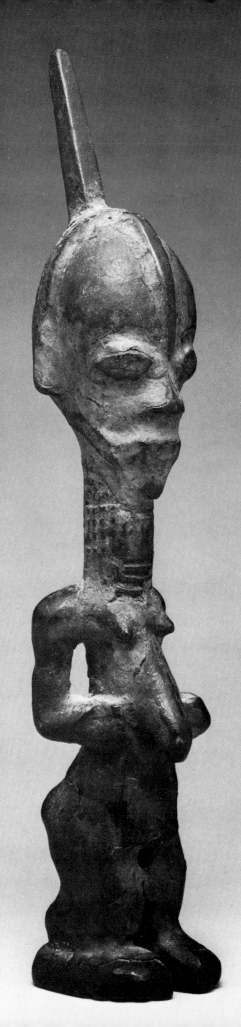

49

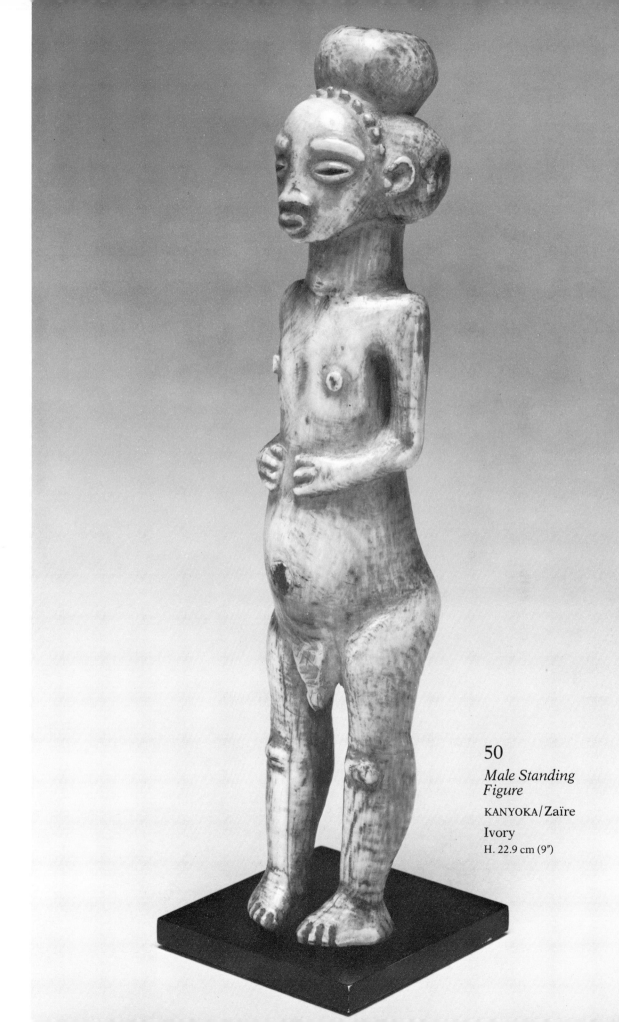

48
Female Standing Figure
LULUWA/Zaïre
Wood, traces of kaolin
H. 17.8 cm (7")

49
Female Standing Figure
LULUWA/Zaïre
Wood, red pigment
H. 21 cm (8¼")

50
Male Standing Figure
KANYOKA/Zaïre
Ivory
H. 22.9 cm (9")

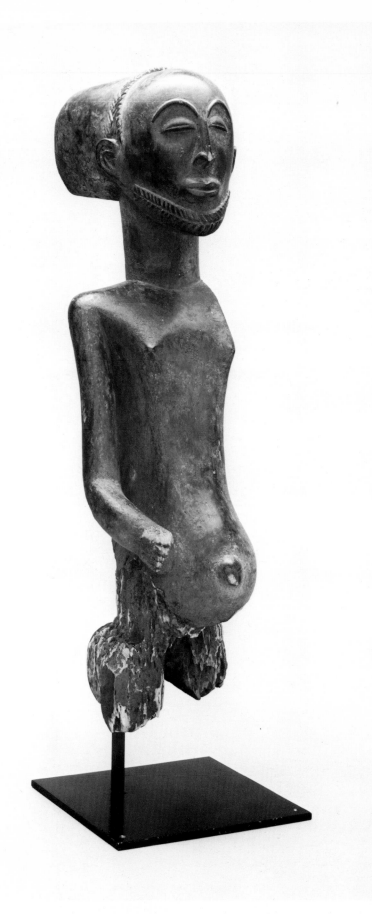

51
Royal Ancestor Figure
HEMBA, LUBA/Zaïre
Wood
H. 60 cm (23⁵/₈″)

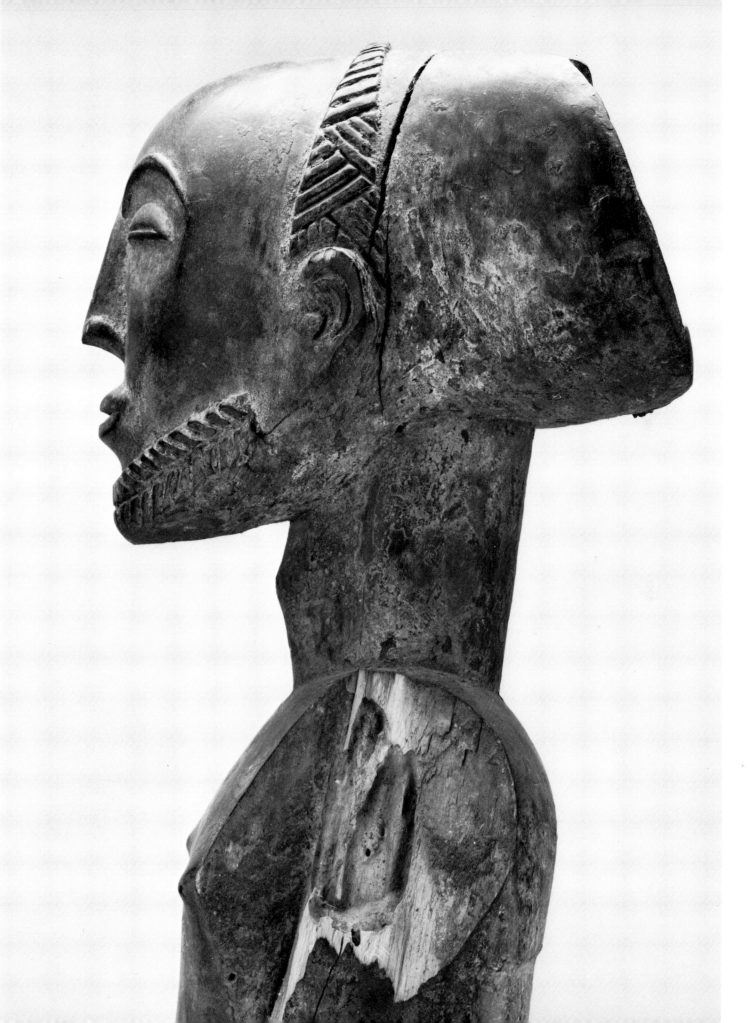

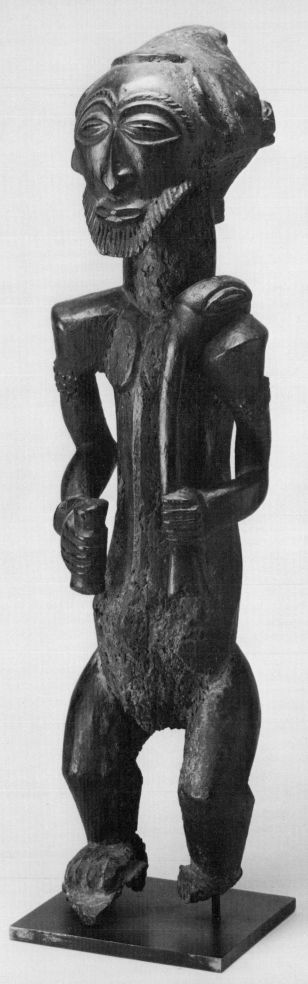

52
Royal Ancestor Figure
HEMBA, LUBA/Zaïre
Wood
H. 65.1 cm (25⅝″)

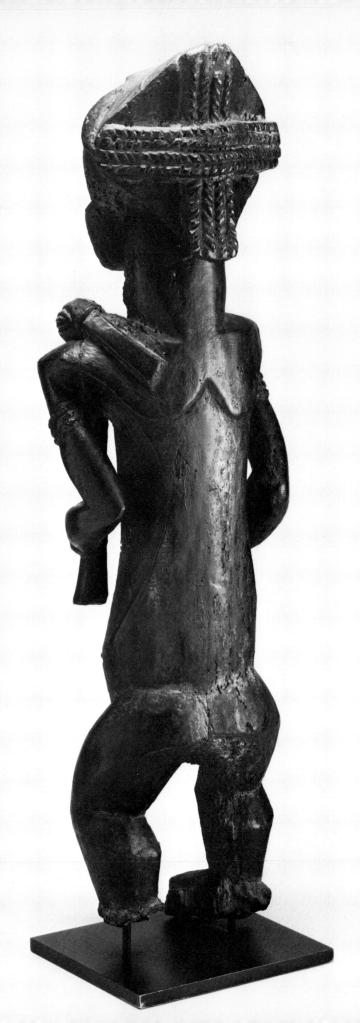

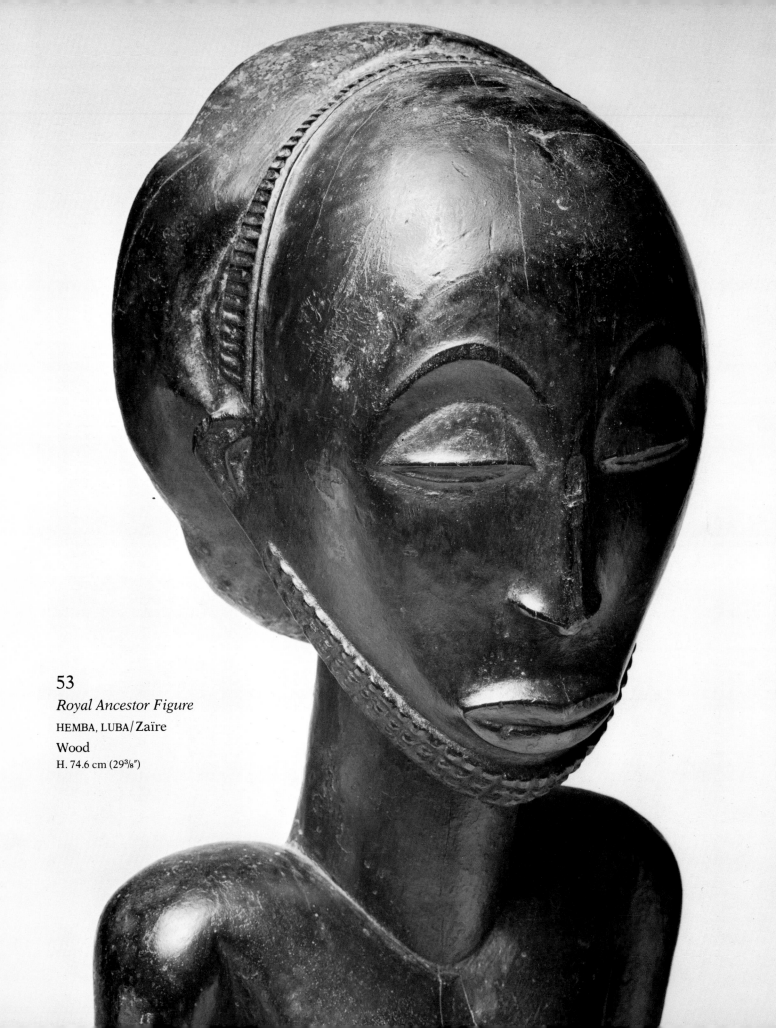

53
Royal Ancestor Figure
HEMBA, LUBA/Zaïre
Wood
H. 74.6 cm (29³⁄₈″)

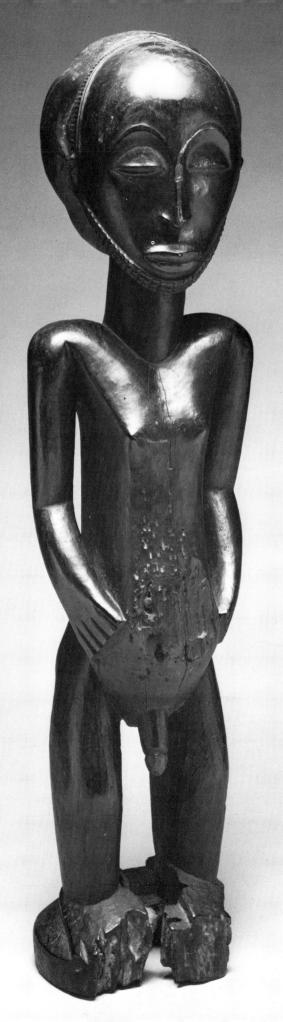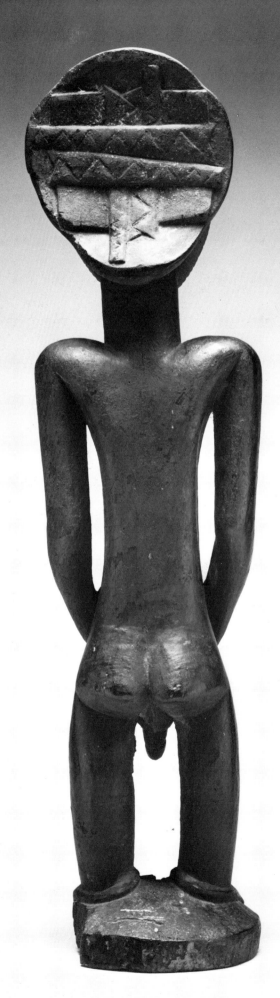

53

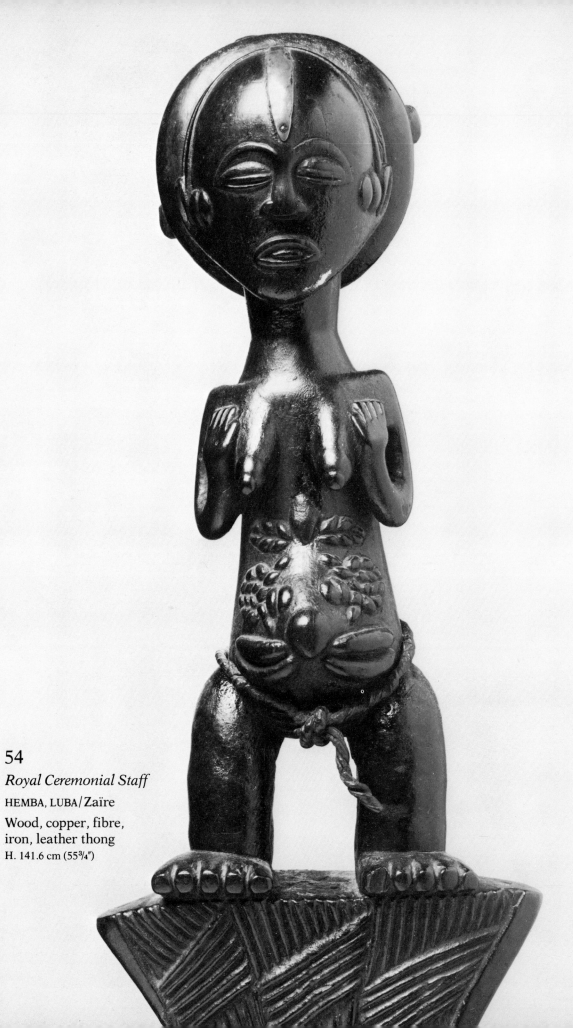

54
Royal Ceremonial Staff
HEMBA, LUBA/Zaïre
Wood, copper, fibre,
iron, leather thong
H. 141.6 cm (55¾″)

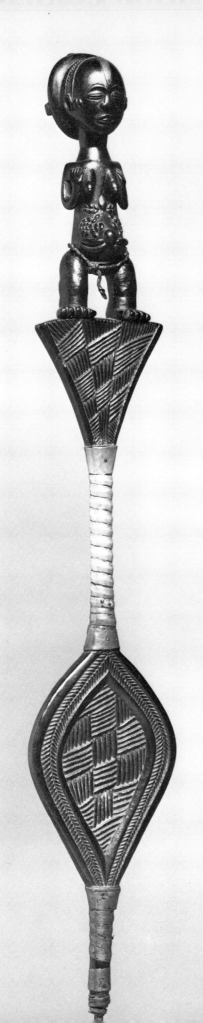

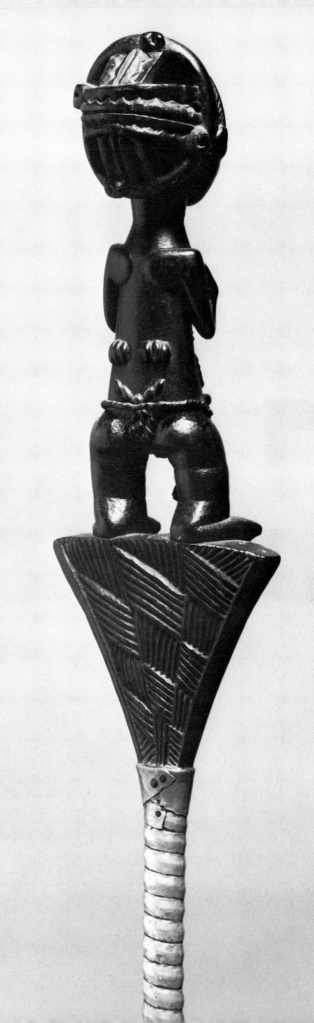

54

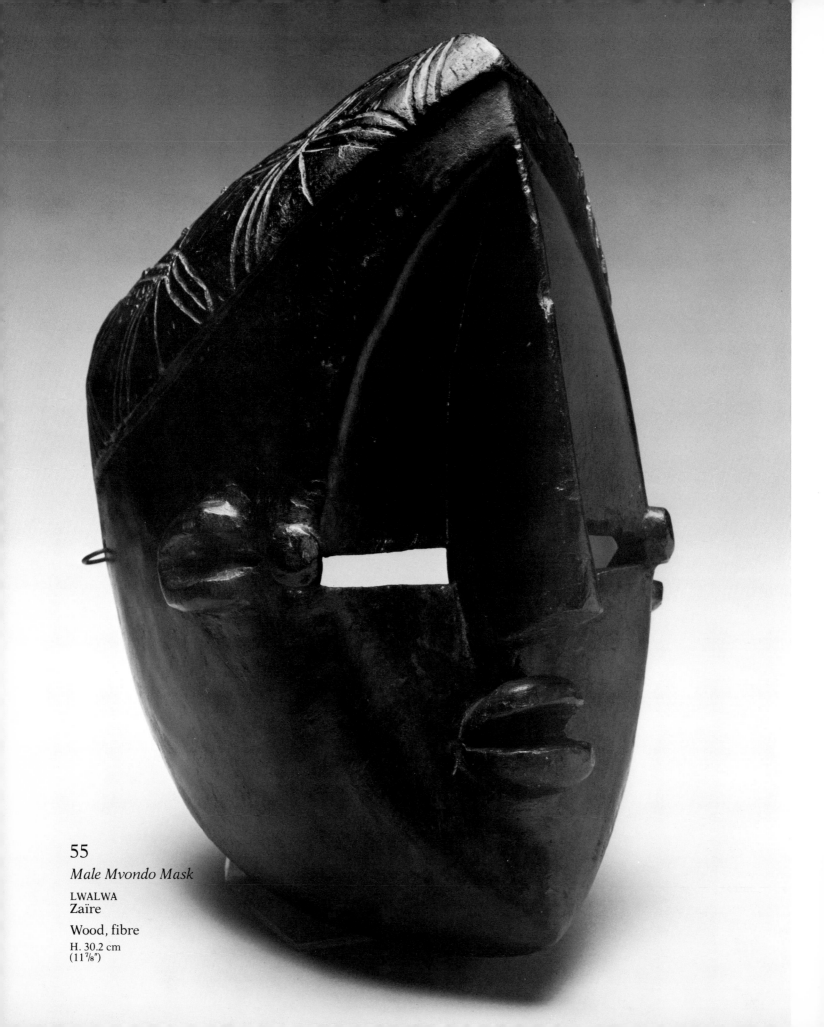

55
Male Mvondo Mask

LWALWA
Zaïre

Wood, fibre
H. 30.2 cm
(11⁷⁄₈″)

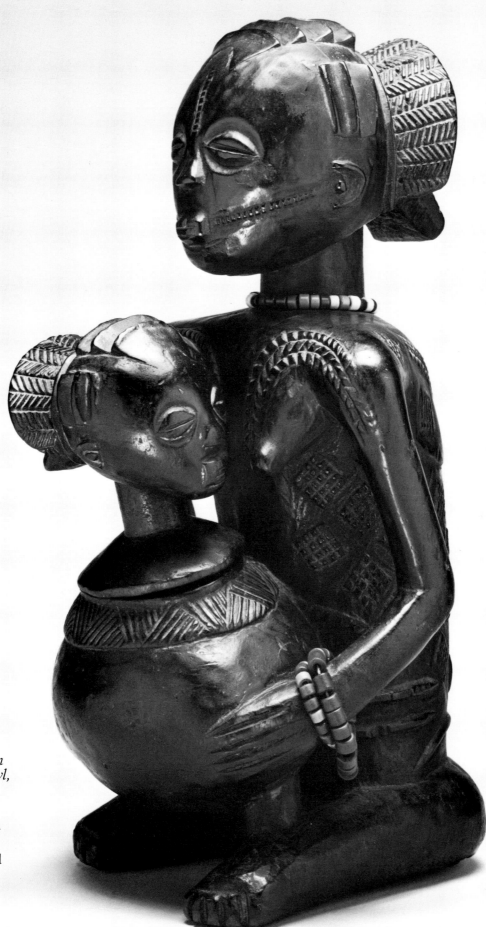

56

*Seated Woman
Holding a Bowl,
Lid in Form
of Child*

SHANKADI, LUBA
Zaïre

Wood, blue and
white beads

H. 47.6 cm
(18¾")

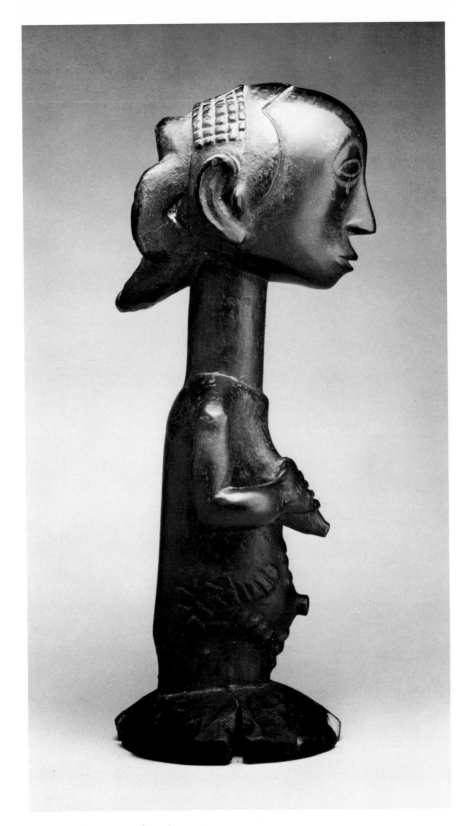

57
Female Calabash Figure
HEMBA, LUBA/Zaïre
Wood
H. 20 cm (7⁷⁄₈″)

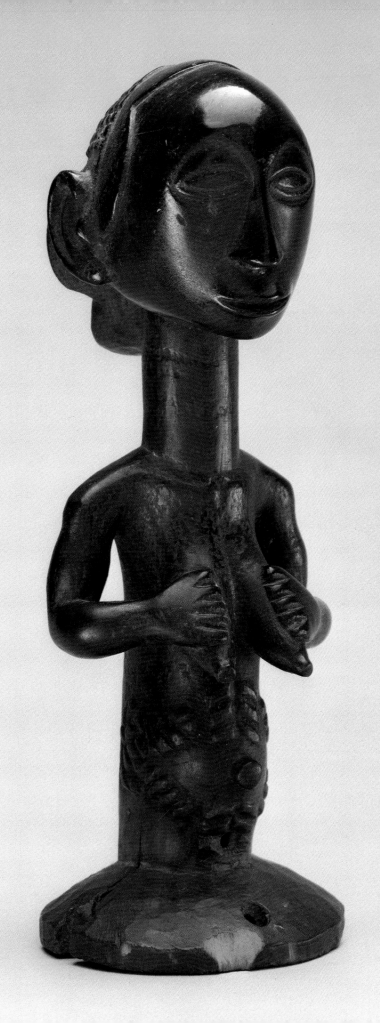

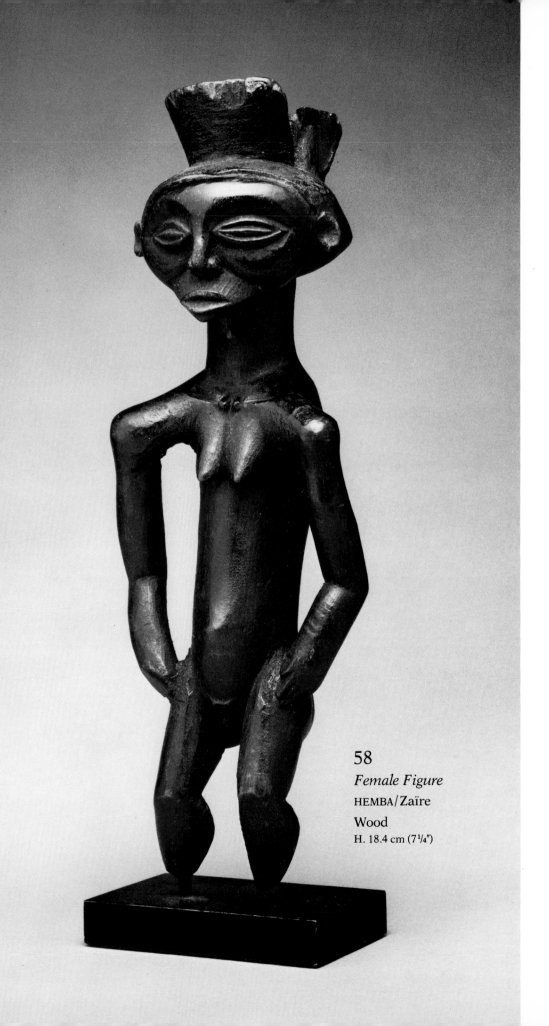

58
Female Figure
HEMBA/Zaïre
Wood
H. 18.4 cm (7¼″)

Sudan

59

Grave Marker

BONGO/Sudan

Wood

H. 182.9 cm (72″)

59

Text by William Fagg

Northern Savannah

1 *Head*
JENNE/ Mali
Terracotta
L. 10.8 cm (4¼")

Once part of a complete figure, this fine male head comes from recent excavations in the Mopti-Jenne area of the Republic of Mali. It belongs to a large group of terracottas that, when they have been tested for thermoluminescence, have been found to date from about AD 1200-1500. These terracottas may have been meant for more than one purpose, since the group includes both realistic figures and grotesque ones, in which, for example, snakes swarm over the body.

Two principal styles of the ancient empire of Mali can be discerned, this style and that of the Konodimini area near Segu. Neither appears to be very closely related to other West African traditions of sculpture, although they do show some affinity with the Sao terracottas of Lake Chad, which are about the same age.

2 *Ancestor Figure (Nomoli)*
SHERBRO/ Sierra Leone
Soapstone
H. 37.5 cm (14¾")

We know little of Sherbro material culture, with the notable exception of these *Nomoli*, or soapstone figures. This piece is an exceptionally large example. The Mende people unearthed these carvings from time to time in the great area of southern Sierra Leone from which they displaced the Sherbro in the middle sixteenth century, therefore dating these carvings as sixteenth-century or earlier. The Mende, who do no stone-carving themselves, believe that these stones have supernatural origins. They use them as gods to promote the fertility of their rice crops and make small shrines for them in the fields.

Nomoli style was used in the fashioning of extraordinary sixteenth-century ivories, carved on commission for Portuguese noblemen by Sherbro carvers. There is a close resemblance between this *Nomoli* and the figures on the ivories, although such blemishes as the bad posture of the right arm and left forearm – undoubtedly the consequence of an unlucky fracture – would not have been accepted in fine ivories.

3 *Horse and Rider*
DOGON/ Mali
Wood, iron, traces of sacrificial coating
H. 56.5 cm (22¼")

A truly magnificent sculpture, *Horse and Rider* is typical of the relatively realistic, rather fluid and cursive forms of the earliest Dogon period in Mali. It is of a type defined by some scholars and dealers as "Tellem." Although we can attribute it at least to the eighteenth or early nineteenth century, the Tellem attribution is unjustified for Dogon sculptures. In the 1950s tomb-robbers made the cleanest sweep in history through the cave cemeteries of the hundred-mile-long Dogon escarpment. According to some sources, they also raided those of an earlier people the Dogon call the "Tellem." There is not a single case where a work can be attributed to a particular cave, so thorough was the tomb-robbers' sweep. Since that time the somewhat prematurely named Dutch Tellem Expeditions under Herman Hahn have not succeeded, after many years of effort, in finding a single work of art in any of the caves that they have so ingeniously entered – not even an identifiable

fragment. While scholars have presumably not explored all the caves in the escarpment, there seems little hope of finding that anything has been forgotten. It also could be that many of the carvings that came out of Mali in the 1950s and were attributed to the caves in fact came from the houses of the *hogon*, or ruling priests.

At the Museum of Primitive Art in New York, Dr. Tamara Northern obtained radio-carbon dates for various Dogon works, but this information has not been published; and unfortunately (for the Dogon at least), radio-carbon dates the death of a tree and not the birth of a work of art. M. Bédaux of the Tellem Expedition, in minimizing the importance of this principle and accepting Dr. Northern's results, overlooks the information given to me in 1969 by Akunyon, the blacksmith of Sangha. He said that because nowadays everybody wants carvings done urgently, carvers use unseasoned wood that can be carved quickly; but in the old days they much preferred well seasoned wood, which took much longer to carve. This statement of course requires verification; but it is consistent with studies of Dogon and other sculpture of the western Sudan. It suggests that a fundamentally different attitude toward the working of wood exists among the tribes in which the blacksmiths are also the woodcarvers, as compared with the tribes of the Guinea Coast, where even hard woods are worked when in a comparatively soft state. The implication is of course that the Dogon smiths would have no means of distinguishing a fifty-year-old piece of wood from one five hundred years old. Although some scholars have noted the scarcity of wood in Dogon country, it has been greatly exaggerated; the men's meeting houses, or *toguna*, need, I was told, to be rebuilt about every twenty-five years, and each one would release several great beams of timber suitable for carving.

4 *Diviner's Charm*
DOGON/Mali
Wood, iron
H. 8.9 cm (3½″)

Probably from early in the nineteenth century, this fine old wooden female charm figure is patinated by long handling in a diviner's bag, or perhaps by use as a pendant.

5 *Primeval Couple*
DOGON/Mali
Wood, iron
H. 57.8 cm (22¾″)

An uncompromisingly cubistic piece, *Primeval Couple* lies at the latter end of the development of Dogon style, as opposed to the earlier, more fluid *Horse and Rider* (No. 3). The evolution of the style is an unbroken chain; there is no suggestion that more than one tribe has been concerned, as those suppose who think that a large number of these pieces were made by the Tellem before 1500.

For the reasons given in describing the *Horse and Rider*, it is possible to attribute only a very few pieces to specific villages. However, there seem to be reasonable grounds for saying that this piece may have been made in Upper or Lower Ogol, villages close to the chief village of Sangha.

6 *Female Standing Figure*
LOBI/Upper Volta
Wood
H. 18.1 cm (7⅛″)

This piece is one of the most sophisticated sculptures from the least sophisticated carving

Nigeria

tribe of West Africa, the Lobi. The carver was evidently a natural sculptor, and his work stands out from most Lobi pieces by being sculpturally formed down to the feet, with a uniformly "alive" surface overall. Other examples tend to have only the head well formed, with the body falling away to a stump or to perfunctorily executed limbs.

7 Ceremonial Ram's Head
BOZO/Mali

Wood, kaolin, iron, felt
H. 49.2 cm (19⅜")

The very rare animal masks from the Bozo tribe of the Niger Bend, who are known as the Niger watermen, seem for the most part not designed for wear on the head, but rather on some kind of harness or construction. According to Germaine Dieterlen and Youssouf Cissé in *Twenty-Five African Sculptures* (J. Fry, ed., 1978, p. 52), this mask

> is attached to the end of a handle that is manipulated by the dancer. The robe of the mask, which is worn by the dancer, has a frame made of branches and is covered with wild rice straw that trails on the ground.

The ram (*saka*) is very important as a sacrificial animal, not only among the Bozo but also among the Bambara and Malinke as well. The mask is made from the lightest and easiest to carve of all West African wood, the silk-cotton tree or "bombax." This head is a fine one, dating no doubt from early in this century.

8 Horse and Rider
YORUBA/Nigeria

Ivory
H. 19.1 cm (7½")

Famous as they are for wood-carving, the Yoruba are also among Africa's finest workers in ivory. Along with the mother and child, mounted warriors are a favourite subject, the horse tending to be reduced in scale in order to emphasize the greater importance of the rider. Kenneth C. Murray has noted that the best Yoruba artists conform to a pan-Yoruban ideal style, and his theory works very well when applied to ivories. In fact, many ivories resist classification, even into broad categories such as eastern or western Yorubaland. Good diagnostic features such as the ear form are often absent because they are concealed by the headgear. The fact that ivories are mostly on a miniature scale reduces differences even further. My own feeling is that, while Murray's theory offers insight in some situations, it is not useful for general application, and breaks down if elevated into a rule.

The form of the scarification marks on the rider's face may indicate that this piece is from the central area around Efon-Alaye. The treatment of the *accoutrements* is also consistent with such an origin, although similar styles to the east are also influenced by Efon work, such as those of Ondo, Akure, and Owo. The holes in the rider's cap are presumably for the insertion of inlay rather than for projecting pieces, and this might well be indicative of Owo work.

9

Gelede Mask

YORUBA/ Nigeria

Wood, traces of pigment

L. 31.8 cm (12½")

This Gelede mask is carved in the classic style of Ota (Otta), a carving village for Lagos in the generation immediately before World War II. Robert Farris Thompson has attributed this mask to the carver Labintan of Ota in the late nineteenth or early twentieth century in *Twenty-Five African Sculptures* (J. Fry, ed., 1978, p. 58). I would wish to do some intensive work on specimens and archives at the Lagos Museum before choosing between the two master carvers, Labintan and Olaniyan. Both of them did carvings for Kenneth C. Murray, who was later to become Surveyor of Antiquities in Nigeria. In the course of some interesting experiments, the two artists showed the capacity to work in exactly the same style, and also to make exact copies of works from Abeokuta and elsewhere, substantiating Murray's theory that the finest Yoruba carvers tend to conform to a Yoruba ideal wherever they work (*see also* Nos. 8, 13). In 1949 I visited their workshop with Murray and we found that both had died some years before. One of their sons, an untrained fifteen-year-old schoolboy, had been prevailed upon to attempt some *ibeji* carvings (twin carvings used in cult rituals) for *onibeji* (people who have *ibeji*) in the absence of any other carver in the village, and we acquired a just-completed pair.

Like most *Gelede* masks, this mask is a feminine one. The *Gelede* is a religious society that dances these masks at yearly festivals and at funerals. The cult's purpose is to appease the witches, since witchcraft is presumed to be an element in all womankind. Because the cult neutralizes the effects of witchcraft on the community, in 1952 the Atinga, a witch-finding cult from Dahomey, attacked all other cults in west Yorubaland, but left the *Gelede* undisturbed.

10

Horse and Rider

YORUBA/ Nigeria

Wood, beads

H. 65.4 cm (25¾")

This powerful carving was undoubtedly made, perhaps as one of a pair, to stand beside the throne in the reception court of an *Oba*, or king. The rich decoration usually found on large Yoruba carvings of horsemen has been rigorously omitted, evidently for architectonic effect. Even the rider's legs are subordinated to the great splayed legs of the horse. The carving probably represented a retainer of the *Oba*, one who, in the old days, would have gone out to war on his behalf. The work is by a highly idiosyncratic master, probably from the region around Oshogbo in northern Yorubaland.

11

Kneeling Female (Odo Shango)

YORUBA/ Nigeria

Wood, red and white glass beads

H. 40.6 cm (16")

A very successful and original sculpture, the *Kneeling Female's* extraordinary body seems from the rear to present some of the features of a shield or animal's shell. It is perhaps the least typical *Odo Shango*, or mortar of the Shango cult. When it is turned upside-down (the way a traditional Yoruba mortar is used), it has only a very small, rough excavation. Shango mortars normally have quite large, crudely hacked out depressions. It is also

rare that the mortar is accommodated within a single figure, and at first sight one is doubtful whether it is indeed a Shango mortar. R.F. Thompson has noted (*Twenty-Five African Sculptures*, J. Fry, ed., 1978, p. 114; *see also* Kurt Krieger, *Westafrikanische Plastik I*, 1965, plates 49, 51) that this piece is by the same hand as certain pieces collected by Leo Frobenius, but Thompson makes no precise attribution. The style is that of the Gbongan district, about fifteen miles west of Ife. Works in this style are also found in Modakeke, the twin town of Ife, founded in the nineteenth century as a settlement for Owo refugees, including some from Gbongan.

12	*Epa Mask*
	YORUBA/Nigeria
	Wood, paint
	H. 82.2 cm (32⅜″)

Surmounted by a female figure, this mask may be classed as an *Epa* mask, the name most widely given to such masks in Ekiti and some neighbouring areas. In the large town of Ila-Orangun, however, the mask and the cult are called *elefon*, and a slightly different form of mask is used. (However, two typical *Epa* masks made by Bamgboye of Odo-Owa, some thirty miles away, were in use in Ila in 1969 under the name of *elefon*.) This style, of which the present mask is a good example, appears to be associated with the Fakeye carving house, and the tall headdress is characteristic of the elder Fakeye, father of Lamidi Fakeye, the contemporary carver. It was probably made in the 1930s.

13	*Divination Bowl: Mother and Child (Agere Ifa)*
	YORUBA/Nigeria
	Wood, glass beads
	H. 25.1 cm (9⅞″)

Again and again the great Yoruba master carvers have been inspired by the all-around, miniature form for their finest work. As we see in this bowl, some of the finest of Yoruba carvings are described within a strictly controlled cylinder. The diameter of the bowl is fixed by the capacity of a diviner's hand to scoop up sixteen palm nuts from it, which he then throws, observing the pattern of these falls in order to read the oracle. The ritual is meant both to predict and influence fate.

Agere Ifa (divination bowls) are among the most universally produced Yoruba works of art. The form tends to serve more as a vehicle for virtuoso carving than for the celebration of Ifa, the god of fate, cosmic order, and wisdom. This no doubt accounts for the fact that the subjects are generally secular. This piece has the most common of all subjects, the mother with a child on her back. Obviously the priests who commission these *Agere* could without difficulty prescribe less secular content; we may assume that the priests, like the carvers themselves, are pleased when the artists display their finest work in Ifa's service.

Another tendency of virtuoso carving on *Agere* is to conform to an ideal pan-Yoruba style, rather than to local variations. Kenneth C. Murray noted this tendency in various art forms among the best Yoruba sculptors (*see also* Nos. 8, 9). It accounts for the remarkable homogeneity of the best Yoruba style among a population estimated at ten million. The long marks on the thighs in this sculpture, as well as some other indications, suggest that it may have been carved around the centre of Yorubaland

in the region of Efon-Alaye and Ife. The mother's typical Yoruba cap, turned up at the corners, seems to emphasize her generality.

14 Royal Armlet
OWO, YORUBA/Nigeria
Ivory
H. 14 cm (5½")

This very fine ornament for ceremonial dress is a welcome addition to the growing corpus of Owo works. There can be no doubt that it originates from Owo in east Yorubaland, close to the border of the Benin Kingdom. The style of the two human figures is exactly like that of the famous ivory ceremonial swords, of which at least three are known, as well as that of a relevant fragment in the Tishman Collection in New York. The form of the ornament is, however, unique in my experience. It is complete in its present state and is only a half-round, so that it cannot be an orthodox armlet, and it has no holes for attachment to a missing part. However, at Benin there is a tradition of using ivory pieces as decoration on ceremonial clothing; in the case of certain ivory leopards carved in relief, it seems that they must have been attached to the lower arm, to which they fit admirably. This ornament may well have been attached in a somewhat similar way to the upper or lower arm.

The very dark colour, probably caused by frequent applications of palm oil and powdered red camwood, is found also on certain Benin works.

15 Mmwo Mask
IBO (OR IBO-INFLUENCED)/Nigeria
Wood, kaolin, fabric
H. 41.9 cm (16½")

The masquerades of the *Mmwo* society of the Ibo tribe in the Onitsha-Awka area are the best-known in Iboland, a land famous for the richness, great number, and astonishing variety of its masked dances. Most *Mmwo* masks are white-faced and represent beautiful dead girls, to appease whose spirits the dances are put on. The masks also include a much smaller number of male masks, usually black and conceived in a much more powerful mould.

This prestigious masquerade has often been imitated, both among the Ibo (elements derived from it have appeared in other masquerades in distant parts of Iboland) and among other peoples speaking different languages. Of the northern Edo-speakers, Jean Borgatti has recorded it among the Okpella (*see* her article in *African Arts*, Vol. IX, no. 4, July 1979).

This female mask is in various details different from the standard form current in the Onitsha-Awka region, but may be a little known variant from a village within the area. On the other hand, it may have come from one of the Edo tribes west of the Niger, and seems to have a certain affinity with the Okpella masks. It is not clear whether the mask was exported from Iboland or whether it was copied from Ibo models or from memory.

16 Statue of an Ancestor (Ekpu)

ORON/Nigeria

Wood
H. 60.3 cm (23¾")

For sculptural originality, the ancestor figures (*Ekpu*) of the Oron clan of the Ibibio tribe, located at the estuary of the Calabar and Cross Rivers, are probably superior to the collected works of any other tribe, even the Fang or the Luba Hemba. The history of the *Ekpu* is pre-eminently a tragic one, unequalled even by the dispersal of the museum collections of Zaïre during the Civil War. They were made, it is thought, over the period 1750-1900 and were all rotting away on outdoor shrines by 1940, when Kenneth C. Murray gathered six hundred or more of the best preserved ones into a temporary museum and photographed them. In 1958 a Malian dealer stole twenty-three of the pieces from the museum. They were quickly disbursed around the world, although many of them were eventually recovered. At the outbreak of the Biafran War in 1967 the remainder were housed in a fine new museum, but soon the museum found itself on the front lines of the Biafran side. Biafran authorities had the figures evacuated to Umuahia, which was to be their final redoubt. After Biafra's surrender, prisoners of war were billeted in the school where the *Ekpu* were kept, and before they were discovered the prisoners had burned more than two-thirds of them for firewood.

Among the abnormally high proportion of first-class works in the Oron corpus, the remarkable design of this figure still comes as a surprise, with its extraordinary waisted triangle for a head, and the more than usually uncompromising trunk and limbs. It is probable that not a particle remains of the original surface, suggesting that the figure should be dated at least to the early nineteenth century. The effect of its deterioration is a softening of outlines and volumes, giving a still more ghostly appearance.

The most extensive publication on the Oron is still Kenneth C. Murray's original article in the *Burlington Magazine*, 1940. A publication containing the complete original photographs of the great collection of the Oron Museum, taken about 1945, is in preparation by the Nigerian Department of Antiquities.

17 Triple-Faced Helmet Mask

EKOI/Nigeria

Wood, painted skin, metal, bone
H. 45.7 cm (18")

The late director of the Museum of Primitive Art, Robert Goldwater, used to call this style "magic realism," and indeed this mask has a kind of super-charged photographic naturalism, a realism raised to a higher power. Keith Nicklin of the National Museum of Nigeria has drawn attention to the similarity of this piece to one, located in the Nigerian Museum in Lagos, that came from the Nkum tribe on the Cross River near Ikom (*see* Ekpo Eyo, *Two Thousand Years of Nigerian Art*, 1977, p. 220). He notes also this mask's even closer resemblance to two janiform masks in the Museum of Mankind, London, collected early in this century.

The piece is a skin-covered wooden mask with a male and two female heads. The style is native to the Ekoi (or Ejagham) groups along the Cross River, including the Bokyi (or Boki), the Keaka, and the Anyang. These tribes span the Nigeria-Cameroon border and are "semi-Bantu-speakers" like their western neighbours, the Ibibio, who have

borrowed the style. Surprisingly, they have propagated it among the Ibo of the Aba and Bende areas, who speak a quite different language, one of the great Kwa group.

Multiple masks like this one, which was formerly in the Pitt Rivers Museum at Farnham in Dorset, are used in the masquerades of the *Nkang*, or warriors' association. In two-faced and three-faced masks the large or main face, which is male, is usually coloured with a dark pigment (probably the sap of a tree called *Bosque anguilensis*). The female face or faces are left uncoloured except for the hair, eyebrows, and tribal marks, which are coloured dark brown like the male face. In this case, however, almost a century's exposure to strong sunlight in the Pitt Rivers Museum has bleached out most of the pigment.

18 Mask
BOKYI/Nigeria

Wood, fabric, skin, raffia, paint, horsehair
H. 39.4 cm (15½")

The cloth-covered wooden pegs in the idiosyncratic head ornament identify this wooden mask as Bokyi (Boki), one of the smaller Cross River tribes. Probably the majority of Bokyi masks are not skin-covered; the faces are carved to simulate skin. See for example M. Charles Ratton's double mask (W. Fagg, *Tribes and Forms in African Art*, 1965, no. 58), which is clearly from an earlier generation, perhaps about World War I. The present piece may be from around World War II, although I can trace no evidence of the feedback from European ideas that was by then affecting the art of so many tribes. It would seem that they managed to preserve their old customs and masquerades longer than others in their remote backwater.

19 Standing Male Figure
KEAKA/Nigeria

Wood, encrustations
H. 52.1 cm (20½")

The rare sculptures attributed to the Keaka tribe nearly all have the ghostly character of this male figure. With these pieces the little-known Keaka made a sometimes striking contribution to the concretization of ghosts (or "deads"), a particular preoccupation of Keaka sculptors. The Cross River tribes – together with the Oron clan of the Ibibio and the makers of the *Akwanshi* or stone monoliths of the Ikom area – are distinguished among West African peoples for this type of sculpture.

Cameroon

20 *Door Frame*

BAMILEKE, KINGDOM OF BAHAM / Cameroon

Wood, traces of pigment

Left side: H. 256 cm (100³/₄")
Right side: H. 264.2 cm (104")

The left-hand portion of this impressive doorway was still in Africa as recently as 1957, as can be seen from Pierre Harter's photo in *Twenty-Five African Sculptures* (J. Fry, ed., 1978, fig. 36) taken *in situ*. The right-hand portion had been taken from Africa to Europe at least two or three decades before. They are now again united in the Frum Collection, and efforts are being made to trace further fragments.

According to Harter (*Twenty-Five African Sculptures*, p. 129), carved door frames like these are the exclusive perquisites of kings and are found only on residences belonging to the palace. Harter describes the carving on these door frames as anecdotal, recalling military victories or other outstanding events. The left one here, for example, tells of the execution by hanging of a queen's lover. The second figure from the bottom is a *Tchinda* (servant) holding the head of an illegitimate child, decapitated as soon as he was born. Below, the king continues to smoke his pipe in the company of another queen, who prepares to pour palmwine into his libation horn. The figures were originally polychrome, coloured in white, red, and ochre.

Frames like this one would have been completed by a lintel and a sill with some carving on them, as can be seen in the oldest photograph of this piece that has yet come to light (*see* frontispiece). The doorway is believed to have been carved toward the end of the nineteenth century during the reign of the twelfth *Fon* (king) of Baham, Pokam, who is seen sitting before it in Christol's 1925 photograph. The range of subjects is suggestive of an African Hieronymus Bosch, including such cautionary stories (widespread in Grassland palace sculpture) as that of a man hanged for adultery with one of the king's wives. While this sculpture may refer to an actual occurrence, it seems more likely to be a generalized warning, possibly exaggerating the rigours of the law.

A photograph of a complete jamb by the same artist, collected by Adametz for Berlin's Völkerkunde Museum in 1903, is published in Kurt Krieger's *Westafrikanische Plastik III*, 1969, pl. 51. The Cameroon Grassland (or Grassfield) is, by common consent, among the most pleasant and beautiful in all Africa. And in this landscape, visibly volcanic in origin, there have been created many of the most potent sculptural symbols of the life force, especially the royal effigies in which the Frum Collection is so strong. In the Grassland, as in the western Sudan, there is a strong preference for matt surfaces in sculpture, as well as for boldly carved, rather than smooth, figures.

21 *Statue of King Nguambo*

BAMILEKE, KINGDOM OF BAKASSA / Cameroon

Wood

H. 157.5 cm (62")

"I can look at a knot in a piece of wood," said William Blake to an apprentice, "until it makes me afraid." This magnificent truncated masterpiece has a truly terrible knot rising through its dominant feature, the great vault of the chest, into which the observer seems to be irresistibly drawn. Pierre Harter notes that "The heart of the tree still seems to be beating in the chest of this statue" (*Twenty-five African Sculptures*, J. Fry, ed., 1978, p. 124).

According to Harter, this colossal wooden effigy represents Nguambo of Bakassa, the great-

grandfather of the present king, *Fon* Ngako, and was carved early in the second half of the nineteenth century. Giantism does not appear to have been uncommon among the Grassland *Fon*s (some possibly owing their position in part to natural selection). Nguambo must either have been something of a giant, or hoped to be regarded as more so than he was.

The statue must originally have been even more imposing. In the first place, there must be a strong presumption that the figure (which, says Harter, has been rescued several times from fires in the royal palace), was designed as a throne upon which the successor of the *Fon* would eventually be installed. The seat would have been of normal size, so that a whole semi-circular row of human heads like those surviving beneath the base, as well as a basal ring of wood, have been lost; this would raise the statue by about eight inches.

More serious damage by fire may have been suffered by the head; as Harter notes, "unfortunately, the king's face lacks the vigour of the rest of the statue: it is flat, with encircled, expressionless eyes." I cannot myself conceive that the original carver (and he was very original indeed in his architectonic concept of the body) would not have made a better job of the head, and in particular would have used the freedom given him by the size of the original tree to give the *Fon* a head of substance and sculptural form, instead of a mere wisp when seen in profile. My assumption is that in one of the fires the effigy toppled forward and was not rescued until the face had been so heavily charred that the only way to salvage the whole was to cut back to sound wood and carve a new face. If so, this has been done creditably enough, and it is not easy to see where the original carving ends and the new begins; but the restorer does not seem to have been more than competent. (Harter relates

that all the thick patina was scraped off at the time of sale, on the instructions of the well-meaning *Fon* Ngako; there are, however, important compensations in the manner in which it has laid bare the wood.)

In its present state, this is one of the most impressive African sculptures; in its original state, *Fon* Nguambo must have seemed, symbolically, not merely the father of his people, but their sheltering protector as well.

22 *Commemorative Statue of a Queen with Child*

KINGDOM OF BANGANGTE/Cameroon

Wood

H. 123.8 cm (48¾")

This wooden figure is that of a queen from the ancestor-cult house of the *Fon* (king) of Bangangte, although according to Pierre Harter it was housed within the *Fon*'s own palace. The queen would be no ordinary queen – the *Fon* might have a hundred or so at any one time. She is queen because she is the mother of a *Fon* (descent running through the female line) or his senior wife. The figure, according to Harter, dates from the 1880s. Very few of the limited number of sculptures of these people remain.

According to Dr. Pierre Harter in a personal communication to Dr. Frum, this is the effigy of the senior queen (*n'gup*) of *Fon* Chachwa of Bangangte who was enthroned about 1880. It was collected before Colonel F.C.C. Egerton's visit in 1935, when he photographed the effigy of Chachwa himself (the identification is Harter's) on the verandah of the palace. In 1966 I visited Bangangte and found that the only effigy that had survived the Bamileke rebellion of a few years earlier was the

now somewhat battered figure of Chachwa. That male figure does not appear to be in the same style as the present one, probably carved by a Bangangte artist, while Chachwa may well have been made by a carver from southeast Bangwa.

Few African tribal carvers (more tradition-bound than modern European artists) would approve of this remarkable sculpture. Even in Cameroon, perhaps those beyond a radius of fifty miles from Bangangte would look askance at it. Apropos of the sculpture's long, pendulous breasts, Egerton, watching thirty-five of Fon Njike's wives performing a shuffling dance, remarked in *African Majesty* (1938): "All but one had the great drooping breasts which are considered beautiful in the Bangangte country." Even more unorthodox are the proportions of the body, especially as seen in profile. But it is perfectly clear that the carver, far from being incapable of following good "African" proportions, was ignoring them in the interest, probably, of better display of the child on the mother's back – emphasized by the posture, not possible in nature, of the child's head.

A similar posture is found in an Idoma sculpture, now in the Museum of Mankind in London, from Jacob Epstein's collection. The piece clearly inspired his great conception of *Lazarus* in New College, Oxford.

23 Dance Staff
BAMILEKE/Cameroon
Wood
H. 48.2 cm (19")

This male figure has the characteristically dynamic qualities of Bamileke sculpture. But the wide-open mouth and the fence of teeth in the upper jaw suggest that it may come from their southwestern borders, where they are open to influences from the Bafo and Bakundu tribes of the plains below the Grassland's escarpment. The figure is perched on its complete, original post and was used as a ceremonial dance staff.

24 Post with Four Heads
BANGWA/Cameroon
Wood, encrustations
H. 118.7 cm (46¾")

Male janus heads (one is hidden from view) here surmount female janus heads on this fine wooden post. These posts are used to define the restricted area where the ceremonies of the night-watch society are held, according to Pierre Harter. Many of the objects collected from the northwestern group of Bangwa (a Bamileke group located to the west of Dschang, but to be distinguished from the southeastern Bangwa, whence they perhaps came) show the same accretions of soot from having been stored in the roof space of dwellings.

25 Statue of a King
BANGWA/Cameroon
Wood
H. 90.8 cm (35¾")

This wooden figure undoubtedly represents a chief or a king (*Fon*), and was used as an ancestor figure after his death. It is a good example of the style of the northwest Bangwa, who carved some of the finest sculptures ever made in Africa. Both the tobacco pipe and the knife or sword held by the chief are symbols of leadership.

26 Statue of Queen Nana with Child
KINGDOM OF BATUFAM, BANGWA/Cameroon
Wood with ochre pigment
H. 101.3 cm (39⁷⁄₈")

The famous figure of a Bangwa female dancer formerly in the Helena Rubinstein Collection is widely regarded as one of the finest of all known works of African art. Although vastly different in conception, this wooden effigy of Queen Nana of Batufam, from the southeast Bangwa chiefdom, is certainly fit to stand beside it. The Bangwa were unique in their ability to suggest movement in a way rarely attempted elsewhere in Africa.

The expressionistic features of the work might have served (but of course did not) as a model for the central figure of André Derain's *Les Baigneuses* (1906), perhaps the first clear case of influence of African forms on the School of Paris. The child on Nana's knee, incidentally, might almost have been plucked from the Baham *Door Frame* (No. 20).

In 1912 *Fon* (king) Metang, sixth of the line, was waiting for the first of his many wives to prove his virility by becoming pregnant before he could be enthroned. Nana was the first and thus became his senior wife. At Batufam the *Fon* was required (according to Harter) to have effigies made of himself and his wife – to be used in the eventual installation of his successor – within two years of beginning to rule. Therefore Nana's effigy was carved between 1912 and 1914. For the complete set of Batufam sculptures seen *in situ* before their dispersal, see R. Lecoq, *Les Bamilekes*, 1953, plates 92-5. Several of the eight Batufam figures pictured there appear consistent with a southeast Bangwa origin, the earliest undoubtedly going back over a century. For each of the Bangwa regions, therefore, there is probably a good corpus of attributable masterpieces, from which a serious intensive study can begin to be made.

The Bangwa tribe, from which the sculptor of this superb piece came, is to be distinguished from the Bangwa studied by Robert Brain and Adam Pollock (*Bangwa Funerary Sculpture*, 1971); the latter tribe appears to have migrated a century or more ago from the southeast to the northwest of the Bamileke region, a distance approaching a hundred miles. The Bangwas now are a chiefdom very close to Batufam. (There are in German museum collections made before 1914 a number of pieces attributed simply to Bangwa; it is almost certain that they should be divided into two groups, Bangwa and Batufam, and there is urgent need for some careful research on the documentation of the early travellers to this end).

The sculpture of the Cameroon Grassland has yet to attain the acclaim that it deserves from the art world. If and when it does so, this piece will certainly have an outstanding place.

27 Wax Figurine for Metal Casting
BAMUM/Cameroon
Beeswax
H. 7.3 cm (2⁷⁄₈")

The lost-wax casting method requires the artist to consign his work to a stage in which it will disappear and be replaced by a void, made possible by the enveloping of the wax in clay to which heat is then applied. The situation is restored by the pouring-in of the molten brass, and both mould and model are lost as the debris is thrown away and the casting emerges.

Foumban, capital town of the Bamum in the French Grassland, is today one of the most highly

developed centres of brass-casting, although it is not certain that it can be traced back beyond the days of Sultan Njoya in the 1890s. This male figure is a musician from a *genre* group representing an orchestra. Some of these may have been made for the Sultan's palace, and certainly many more were made for export to Europeans. The most elaborate ones combine a marvellous blend of German *Jugendstil* (art nouveau) with the fantastic possibilities of Cameroonian imagination, which is still preserved and fully alive at Magbo chiefdom near Foumban, presumably since the early reign of Sultan Njoya.

About fifty years ago a small colony of Bamum brass-founders migrated from Foumban to Bamenda, the chief town of the British Grassland, where they could better serve the British administrators and others from Nigeria going to the Grassland on local leave. The same style was practised at the two centres, so it is impossible to say at which town this piece originated.

28	*Standing Male Figure*
	BAMENDA/Cameroon
	Wood
	H. 23.5 cm (9¼")

The elusive style of this male figure is known to come from the former British Cameroons, and specifically from the Bamenda Highlands, but it has not been possible to pinpoint it more closely. I have not found examples of this precise style in the early collections of German museums, but the British Museum acquired one in the late twenties. It must have been a new style, perhaps used for early tourist pieces for the British. There is, however, a fine old stool with similar nose and eyes in the Linden-Museum, Stuttgart, from which it may have been derived. There is a large number of these objects, collected by M.D.W. Jeffreys in the thirties, in the Pitt Rivers Museum, Oxford, but they were never documented with a place of origin. The asymmetrical posture of the arms is very frequently seen in this style, as is the peculiar flat rectangular head. This piece is one of the best examples of the type and was almost certainly from the twenties.

Gabon

29 *Reliquary Figure*
KOTA/Gabon
Wood, iron, brass, copper
H. 53 cm (20⅞″)

This superb brass-covered wooden sculpture, from the northern fringes of the Obamba subtribe around the town of Okondja on the Sebe River, presents a striking contrast to the style of *Reliquary Figure* (No. 33). It is an exercise in near-abstraction based on very subtle planes in low relief, perhaps comparable in modern art to the work of Ben Nicholson. Here the surrounding forms are still flat, but serve as a contrasting surface from which projects the massive three-dimensional head, with no trace of foreshortening. In this very rare sculpture the surpassing coolness of Kota *Reliquary Figure* (No. 33) gives way to the warmth and energy of the human form.

Louis Perrois in *Twenty-Five African Sculptures* (J. Fry, ed., 1978, p. 144) says in describing this piece:

> The great majority of African "works of art"... are considered essentially ritual instruments by their users.... But the coming together of technical excellence, a taste for fine forms, and an inspiration both aesthetic and mystical, have culminated in several masterpieces of universal significance, among which is the sculpture depicted here.

30 *Reliquary Figure (Byeri)*
FANG/Gabon
Wood, palm oil
H. 40 cm (15¾″)

The Fang were among the most feared warriors and cannibals in all Africa, yet the heads and figures they carved for their ancestor cult are classical examples of the serene beauty of which African art is capable. This admirable female figure is in the typical style, with "flying" hair, of the *Byeri* (reliquary figures) of the Nzaman-Betsi peoples who are the southernmost Fang. According to Louis Perrois, the patina is a resinous mixture of palm oil (widely used in West Africa) and copal. Once the wood is impregnated thoroughly with this mixture, it exudes oil indefinitely. Throughout the vast Fang area, such figures are both evocations of the dead and magical protectors of the ancestral bones. The ancestor's skull and some of his small bones were kept in boxes made of bark and the statues were attached to the lids with vines.

In the 1920s the famous Paris dealer Paul Guillaume gave fifth- and sixth-century attributions to some of his *Byeri* figures. Now, with better ethnographic information, it seems more probable that they were carved within the last two-hundred years. The form finally died out between 1914 and 1930, according to Perrois, because of the combined forces of Christianity and a determined colonial administration.

31 *Reliquary Figure with Basket*
KOTA/Gabon
Wood, metal, bone, fibre
H. 43.8 cm (17¼″)

In the history of the Kota complex, these miniature ancestor figures have a considerable importance. What specific role they played, however, is not yet understood. There is a similar lack of unanimity over their precise origin, although they are most widely described as Ondumbo.

32

Reliquary Figure (Bwete)

MAHONGWE, KOTA/ Gabon

Wood, corroded brass, copper, iron
H. 55.9 cm (22")

The Mahongwe who created very abstract inter-
pretations of the human figure are the north-
ernmost segment of the Kota complex. As among
the Obamba and other Kota, such figures repre-
sent the ancestors of the family. They do duty as
protectors of the ancestral relics on the shrine and
are used, as well, in the ritual of resurrecting the
dead in the initiation ceremonies of the tribe. The
brass and copper used in these sculptures were
introduced by Europeans in the eighteenth cen-
tury as currency. The metal was adopted by the
Mahongwe, not as an adjunct but as an integral
part of the representation to do honour to their
ancestors. Yet despite this partly European origin
of the figures, missionaries in the early days waged
implacable war against the *bwete* and their attend-
ant customs, and were usually successful in de-
stroying them. Some were buried in deep pits.

This wooden piece covered with brass wire is
one of a cache that came to light some years ago. It
is undoubtedly a nineteenth-century work.

33

Reliquary Figure

KOTA/ Gabon

Wood, brass, copper, iron
H. 50.1 cm (19¾")

There is a marvellous precision about the design
and execution of this brass-covered wooden work,
and indeed it would seem that the artist was con-
sciously seeking perfection. The style is that of the
Obamba subtribe of the Kota tribe, situated to the
south of Okondja, between the rivers Sebe and

Lekoni. Other practitioners of this subtribe do not
dare – or care – to emulate him.

Reliquary figures are representations of ances-
tors. As they do among the Fang tribe, they serve
the subsidiary function of protecting the ancestral
relics from evil influences. In addition they seem to
have had the important purpose of serving as pup-
pets in masquerades during tribal initiation cere-
monies, which were supposed to bring the dead to
life. This function no doubt explains the open
lozenge shape that serves as the body.

Congo

34 *Royal Sceptre*
YOMBE, KONGO/Zaïre
Wood, beads
H. 85.7 cm (33¾")

35 *Seated Female with Child*
YOMBE, KONGO/Zaïre
Wood, glass
H. 27 cm (10⅝")

There is an extraordinary richness, variety, and number of sceptres of sacral kingships or chieftainships from the Lower Congo area. Among the large number of fine sceptres this wooden one in the form of a mother and child stands out as one of the best. Its importance may be gauged from the great similarity it bears to No. 35, *Seated Female with Child*, one of the great masterpieces of Kongo art. It is not, however, by the same hand and should not be assumed to have the same meaning. The mother and child here may be a reference to royal matrilineal descent, representing an ancestor immediate or primordial; or it may represent the general idea of an ancestor or all ancestors, or even fertility itself.

The patterned cap and waistcloth are representations of royal embroidered raffia cloth, with either cut or uncut pile, similar to examples preserved since the seventeenth century in the National Museum in Copenhagen, the Museo Pigorini in Rome, and the Museum of Mankind in London. The necklace is of leopard teeth, a royal prerogative.

I believe it is not entirely fanciful to accord these sceptres an importance comparable to that of the particles of the true Cross as sanction of the apostolic succession of the priesthood in the tradition of the Christian church. Certainly some such explanation is needed to account for the homogeneity of style, despite the great proliferation of autonomous chiefdoms since the head and fount of supreme kingship was removed. A principle of infinite subdivision of chiefdoms may have supervened.

There are six known figures of this type, all by the same hand. They must be ranked among the supreme achievements of the Kongo in the hieratic or sacred style. It is probably too late to recover the identity of this great master.

Huguette Van Geluwe has ably summarized the arguments over the meaning of these pieces in *Twenty-Five African Sculptures*. And Albert Maesen, director of the Royal Museum at Tervuren, Belgium, has aptly noted that we have here "a symbol of fertility itself rather than any particular mother," a symbolic representation of a metaphysical creative force. The absence of emotional expression only accentuates the transcendent detachment of mind. This interpretation may be applied equally to all the pieces by this hand.

All the *accoutrements* of royalty are present, and the beautiful patterns on the back, although they could be a representation of embroidered cloth, are much more likely to represent keloid scarifications, since there are good photographs available of these same patterns.

On some of the other pieces, the hieratic stillness is so marked that some commentators have thought that the child was represented as dead, but this is disproved by the present case which, alone, shows the child with his hand to the mother's breast.

144

36 Female Nail Fetish (Nkondi)

YOMBE, KONGO/Zaïre

Wood, traces of kaolin, iron, fibre, fabric, mirror

H. 74.9 cm (29½")

This figure, unusual because it is a female, appears to be from the Yombe area just north of the mouth of the Congo River. It was formerly part of the great private collection of the dealer W.O. Oldman and is likely to have been acquired by him about 1900-20, although the piece undoubtedly dates from considerably before. After Oldman's famous Polynesian collection went to New Zealand, the British Museum acquired his very fine African and American collections in 1949, which included this figure.

These *Nkondi* (nail fetishes) have been misinterpreted as evil-doers or as expressions of evil-doing, when in fact they seem to have been devoted to good or neutral purposes, as Buddha is protected from harm by horrific yet wholly beneficent guardian spirits. The driving-in of a nail does not intend harm to the corresponding part of the body of an enemy; otherwise, in African practice, they would be concentrated in the head, which is the only part more or less free of iron. As Huguette Van Geluwe says (*Twenty-Five African Sculptures* 1978, p. 153):

> Called upon to destroy evil and evil-doers (*Nkoki*), the spirit of the *Nkondi* must necessarily have recourse to aggressive means. Each *Nkondi* had its own specialty: one was thought to cure epilepsy, another to relieve stomach aches – a third to protect against theft....In the case of death, sickness, theft, or other distress, the victim would approach the diviner to identify the evil or evil-doer involved. Then, on condition of payment the priest would drive a nail or knife-blade or other sharp object into the statue to raise the spirit of vengeance.

37 Female Figure

BEMBE/Zaïre

Wood, canvas

H. 16.5 cm (6½")

The Bembe are among the most accomplished miniaturists of all Africa. Almost all their works are about six or seven inches high, the exceptions being exactly like the small ones but magnified about three or four times. All are crypto-fetishes in the sense that the fetish material applied to them is not placed, as among the other Kongo peoples, in a conspicuous place on the head or the abdomen, but concealed in a discreet anal cavity. These female figures were worn by pregnant women on strings around their necks and were kept under their clothes to insure healthy babies.

The Bembe managed to maintain their own style of art relatively uninfluenced by the vast artistic nexus that still holds sway in the territories of the old Kongo empire, even though the empire broke up in the seventeenth century.

38 Male Figure
KONGO/Zaïre

Wood, glass, paint
H. 33 cm (13")

The basic principles of Kongo style are evident in this carving from the middle nineteenth century – the head is tilted back at an angle of about 45°, the trunk is slightly inclined forward from the hips, and the legs are straight. The Yombe, by comparison, may balance the tilt of the head (*see* the reference to Derain's 1906 painting *Les Baigneuses* under No. 26).

This piece was acquired in the 1890s from the dealer W.D. Webster by Lieutenant General Pitt Rivers.

39 Female Figure
TABWA OR NGBAKA/Zaïre

Wood, brass, cloth, beads
H. 15.9 cm (6¼")

It is curious that virtually the same scarification pattern is employed in two very distant and unconnected tribes of Zaïre, the Ngbaka or Bwaka in the northwest and the Tabwa in the southeast: this is the ladder motif joining the eyes to the ears, together with another bisecting the forehead. It is hard to exclude this little figure from either of these tribal groups, in the absence of comparable miniature carvings, but at present I am inclined to class it with the related cultures around the south end of Lake Tanganyika which are the main extension to the south of Luba influence.

Although the bodily proportions of this figure approximate those of an achondroplastic dwarf, it is unlikely that this was the intention of the artist.

40 Staff
LENGOLA/Zaïre

Wood
H. 69.2 cm (27¼")

The Mongo-speaking Lengola live to the west of the Lega, whose influence can be seen in the faces of this piece. They are, however, unlike the Lega, especially known for tall ancestor figures with spindly torsos and limbs which, contrary to the usual African practice, are detachable.

41 Whistle: Crouching Female Figure
KONGO/Zaïre

Wood
H. 11.4 cm (4½")

Whistles, embellished with exquisite small figures such as this, were used by the medicine men or doctors (*Nganga*) of the Kongo in the course of their rites. The actual whistle was a small antelope horn, pierced at the tip and suspended through the hole, which passes upwards through the body of the figure. The whistle was blown across its broad end.

42 Mask
NGBAKA/Zaïre

Wood, kaolin
H. 24.1 cm (9½")

Masks with scarification based on the ladder motif are most characteristic of the Ngbaka, but are also found among some of their neighbours such as the Ngombe and the Ngbandi. The function of these rare masks is uncertain, but they have an elaborate initiation cult in which masks are certainly used.

43
Alunga Janiform Mask
BEMBE/Zaïre
Wood, red, white, and black pigment
H. 42.2 cm (16⁵/₈")

The Bembe, living on the northwestern shores of Lake Tanganyika, are controlled by the *Alunga*, a powerful society (comparable to the *Bwame* of the Lega or the *Kota* of the Lengola) especially devoted to the initiation of young men and to the cult of the bush spirit of the same name. This mask, called *"Ecwaboka"* according to P.P. Gossiaux (in "Recherches sur l'art bembe," *Arts d'Afrique Noire*, No. 11,1974), represents *Alunga* itself; although omniscient, it is considered to be blind and has to be led. In cult ceremonies the dancers are covered in raffia and sing in a deep, guttural voice. The enormous eye sockets of the mask tend to dominate all Bembe art forms, although generally to a lesser degree than in this one.

44
Standing Female Figure
OVIMBUNDU/Angola
Wood, beads
H. 44.5 cm (17¹/₂")

This exquisite figure has previously been regarded as an aberrant work of the Fang, but the dwindling of the legs is decisively against this, whereas some features seem to fit into the Mbundu (or Ovimbundu) style of south central Angola. This style has been documented by Marie-Louise Bastin as one of the Chokwe-influenced tribes to the south of Bihe (*African Arts*, Vol. II, no. 4, Summer 1969, pp. 30-37, 74-76), however, having seen photographs she is uncertain about the identification.

45
Female Makishi Mask
LWENA/Angola
Wood, fibre, beads
H. 24.8 cm (9³/₄")

This excellent piece is one of the principal masks of the *Makishi* masquerade, found throughout the Chokwe and Chokwe-influenced world in Angola, Zambia, and eastern Zaïre. The character represented by the mask is a young girl of athletic disposition who (in Zambia at least) performs upon two twenty-five-foot poles that are upright in the ground and joined by a slack rope at the top. For photographs illustrating this act *see* William Fagg's *African Tribal Images* (Cleveland, 1968).

In Zambia the old initiation ceremonies have long been abandoned, but the dances are carried on for the entertainment of the overlords of the Chokwe groups, and for tourists. A corresponding deterioration in the quality of these masks over the last fifty years can be seen, although in Angola the old traditions of religion and art have been better maintained.

46
Standing Male Figure
SUKU/Zaïre
Wood
H. 23.8 cm (9³/₈")

In this wonderfully sculptural small work, the sense of almost mechanical motion as one goes around it is irresistible and is greatly contributed to by the opening-up of the body. These effects are perhaps best seen in the side and rear views. The piece is in a similar style to the most famous of all Suku works, the great female figure at Tervuren (*see* Elisofon and Fagg, *The Sculpture of Africa*, 1958, plate 200).

47 *Ceremonial Adze*
WONGO/ Zaïre
Wood, metal
H. 40 cm (15¾")

The Wongo, like the Lele, are an autonomous group of Kuba living between the Kasai and Loange rivers, who never acknowledged the suzerainty of the Kuba kings. Their material culture is considerably simpler than that of the Kuba proper, but it shares many of the same decorative motifs. Wongo woodcarvers, like those of Kubaland and Pendeland to the west, made beautiful ceremonial adzes to wear over the shoulder on formal occasions as a sign of their craft.

48 *Female Standing Figure*
LULUWA/ Zaïre
Wood, traces of kaolin
H. 17.8 cm (7")

49 *Female Standing Figure*
LULUWA/ Zaïre
Wood, red pigment
H. 21 cm (8¼")

It is well known that after about 1880, when the Luluwa migrated under pressure from the Basongye and settled down on the Lulua River near what later became the town of Luluabourg, they made no further large statues, although small-figure carving continued. In fact these little works (of which a great number, including these two, were brought back by Hans Himmelheber from his expedition before World War II) have been the main artistic product of the tribe. They are called *lupfingu*, and the cupped left hand is used to receive offerings of kaolin to the spirits. A lavish use of surface enhancement is in the unmistakeable Luluwa style.

50 *Male Standing Figure*
KANYOKA/ Zaïre
Ivory
H. 22.9 cm (9")

Albert Maesen, Director of the Musée Royal de l'Afrique Centrale, Tervuren, considers this fine piece, acquired by Lt. Gen. Pitt Rivers from W.D. Webster in 1897, to be one of the very rare pieces in the authentic style of the Kanyoka. A reconsideration of accepted views on the art of the Kanyoka is made necessary by Dr. Maesen's work on the Kanyoka style, correcting the work of his predecessor Professor F.M. Olbrechts and others. Maesen believes that virtually all pieces previously identified as Kanyoka in museums, following Olbrechts, to be the work of one man. That carver, of uncertain tribal origin, operated about the turn of the century in the neighbourhood of Kandakanda, the administrative centre of the area, working mainly for the Europeans (*see*, for example, Fagg and Plass, *African Sculpture: An Anthology*, 1964, p. 71) and his style bears no resemblance to the true tribal style of the Kanyoka of which this is an exceedingly rare example.

51 Royal Ancestor Figure
HEMBA, LUBA/Zaïre
Wood
H. 60 cm (23⁵⁄₈")

This figure might perhaps have an even stronger claim to the name "Agamemnon" than the following piece, which has a certain air of humour about it of which this is free; or perhaps it would be better nicknamed Assurbanipal, or Darius the Great. Its authority is absolute.

The piece is classified by François Neyt as coming from the chiefdom of Yambula on the Zaïre River at the western extremity of the Hemba. Four other pieces attributed to this style show some of the same emphasis on the power of the kingship, although not to the extent of this one. The noble brow sweeps aside the sad decay of the lower limbs. Perhaps it is the finest of the three Hemba effigies in this collection.

52 Royal Ancestor Figure
HEMBA, LUBA/Zaïre
Wood
H. 65.1 cm (25⁵⁄₈")

This noble figure, called by François Neyt an "African Agamemnon," is thought by him to have belonged to the family of Chief Simuko of Makutano in southern Mambwe territory to the southeast of the Niembo, although the style may be that of the Hombo or the Bangubangu to the north of the Mambwe.

The effigy bears many of the traditional emblems and *accoutrements* of prestige: rings around the arms and wrists, the ceremonial adze over the left shoulder, the large parade knife with its curved blade missing, as well as the sumptuous hairstyle and beard worn by the chiefs to designate their political authority.

Reviewing the 149 ancestor effigies classified under twelve groups in Neyt's catalogue (*La grande statuaire hemba du Zaïre*, 1978), it is remarkable that this figure stands out, for me at least, from the rest as the one that is most obviously *sui generis*, that is, owes least to the work of others. Unless it is the sole surviving representative of a mode that was formerly that of a whole school, which is extremely unlikely, we must assume that the artist, facing the various sculptural problems of making such an effigy, found his own sculptural solutions. We have then only to consider whether they were successful or not, and there is perhaps no better way of discerning the presence of genius than that.

53 Royal Ancestor Figure
HEMBA, LUBA/Zaïre
Wood
H. 74.6 cm (29³⁄₈")

The art of the Luba, and above all that of the Hemba subtribe, was one of the first to establish itself in Europe. From about 1884 onwards major Luba works were being brought back from the Congo by von Wissmann and other German explorers – more than twenty years before European artists discovered African art. The Hemba style was represented in the early books on tribal

art by pieces which are still among the supreme masterpieces of African art.

A dozen years or so ago, the Hemba subtribe in particular suddenly began to yield up many times the number of royal effigies that were known before, numerous though these had been. We are much in debt to François Neyt for publishing so many of them, although many remain unpublished, including a good number of inferior merit. Most of the *grandes lignes* of Hemba art were indeed known from the early days, but we now have incomparably more detail to fill out the outlines and also, through fieldwork, a certain amount of partly conjectural information on the localization of the styles. There are now far more great masters known, from about the turn of the century or earlier, than anyone expected. This piece is classified in Neyt's work, as the classical southern Niembo style, and is attributed to the Mbulula region. Neyt compares it to the specimen in the Antwerp Ethnographical Museum, and to another fine piece in the Tervuren Museum, saying that they are marked by a slight raising of the shoulders. Indeed, they may well be from the same workshop, although the Antwerp piece has perhaps a superior dynamism, a royal condescension in the slightly bent posture.

54 Royal Ceremonial Staff
HEMBA, LUBA/Zaïre

Wood, copper, fibre, iron, leather thong
H. 141.6 cm (55¾")

It is easy to see that the carver of this royal staff was a master of the Hemba style. The verve with which the two areas of basketry-imitation are treated underlines this fact, as does the unusual size and boldness of the figure. Royal staffs were only carried by the chiefs and stood in the ground outside any dwelling that they might be visiting.

The southern savannah is very open country found to the south of an eastwest line, approximately 4° south latitude, traversing Africa from near the north end of Lake Tanganyika to the mouth of the Congo. It is rather difficult for travellers because of the very large number of rivers, flowing mostly in a south-north direction. In the savannah are many divine kingdoms of ancient standing, which are less characteristic of the forest region. Associated with them is a great wealth of oral history, much of which has now been recorded. The peoples of the southern savannah, and especially the Luba, tend on the whole to prefer polished to matt surfaces in art.

55 Male Mvondo Mask
LWALWA/Zaïre

Wood, fibre
H. 30.2 cm (11⅞")

The Lwalwa do not appear to have much influenced, or been influenced by, their neighbours so far as the design of their masks is concerned. The remarkable extension of the face from top to bottom is hard to parallel not merely in Zaïre but in

all Africa, unless perhaps in some rare Ibo masks. This is one of three types of male masks and is called *Mvondo*. As usual in southern Zaïre, the masks are used in a secret society, the *Ngongo*, which is concerned largely with the initiation of youths. The newly circumcised young men celebrate their entry into the tribe by performing ritual masked dances.

56 Seated Woman Holding a Bowl, Lid in Form of Child
SHANKADI, LUBA / Zaïre

Wood, blue and white beads
H. 47.6 cm (18¾")

Several major styles in Luba art have been identified, Shankadi being one of the two major subdivisions and Hemba the other. The Shankadi in turn had many substyles, one of the finest of them centred around Mwanza, where the carver of this bowl must have been a leading artist of his time around the turn of the century. A number of similar bowls exist, most or all of which bear the imprint of his craftsmanship; *see*, for instance, Gillon, *Collecting African Art*, 1979, p. 131, fig. 163.

The beautiful upper part of the figure is dominated by the two identical heads of the woman and the child, and it seems at least possible that there is here an element of humour. Perhaps we may dub the artist the Master of the Bowl-Babies, recognizing an ambiguity of the sculpturally created metaphor. Let us, by way of experiment, subject the piece to analysis (a breaking up into parts) – quite the wrong method of appreciating a work of art, of course, which is essentially a synthesis – and consider the legs and feet. Confronted by those deformed stumps, shall we not wonder how this

master even passed the first tests of his apprenticeship? Yet if we consider the whole, we see that it is a necessary part of the design, a design we would never think of questioning.

57 Female Calabash Figure
HEMBA, LUBA / Zaïre

Wood
H. 20 cm (7⅞")

This is an outstanding example of one of the most characteristic of Luba art forms. According to François Neyt (*Twenty-Five African Sculptures*, 1978, p. 172) there are fewer figures of this type than there are ancestral pieces. They are always beautifully carved and highly venerated.

Neyt attributes this fetish to the area of Mbulula, one of the centres of the Niembo style. The fetishes, he says, were used by the priests of the *Bagobo* society for magical purposes, although no research has yet been attempted on the rites involved.

Another outstanding example of this style, both for sculptural quality and the richness of its ethnographical attributes, is the masterpiece of the Tristan Tzara Collection (Elisofon and Fagg, *The Sculpture of Africa*, 1958, pl. 297). The shallow cone of the base is not meant to be seen, but would have been attached to the top of a calabash. Ritual ingredients were placed in the top of the head and descended through the hollowed-out figure to be collected in the calabash below.

Sudan

58 *Female Figure*
HEMBA, LUBA/Zaïre
Wood
H. 18.4 cm (7¼")

This beautiful little figure, perhaps of Hemba origin, is remarkable for the horizontalization of the head (as opposed, for example, to the verticalization of the head of No.57). The strong element of abstraction, however, blends well with the naturalism of the rest of the figure. The bones around the neck and shoulders and the contours of the back are marked with especial care.

The purpose of such figures is not known, although Albert Maesen believes that they represent protective spirits and are used in several cult societies. He also suggests that the figure's hairstyle places it in the northern Shaba.

59 *Grave Marker*
BONGO/Sudan
Wood
H. 182.9 cm (72")

In the art of the Bongo (and, according to Evans Pritchard, their neighbours the Bellanda) we see African art reduced to its basic rudiments, the simplest kind of pole sculpture that might almost have been carved on a living tree. For something between five and ten thousand years in this area of the southern Sudan, the Bongo or their predecessors have maintained this genuinely primitive art, unchanged in essence from the time when there was no other African art.

This particular sculpture can hardly be older than the nineteenth century. Consequently, when we consider it on a time scale of several millennia, we have left well behind us the possibility of finding direct links to the art of those early times. Nevertheless there seems no reason why we should not give a free rein to speculation and subjective judgement. The hypothesis I am entertaining is the assumption that this is the general area from which, or through which, the art of sculpture was diffused throughout Africa south of the Sahara. Certainly, the Bongo were the principal purveyors of art to surrounding tribes such as the Azande. Nevertheless, to the end they preserved the elemental character of their work, with little or no decoration.